D0780214

GLENWOOD SPRINGS PUBLIC LIBRARY

DISCARDED FROM LIBRARY
GARFIELD COUNTY PUBLIC LIBRARY

DOUBLEDAY & COMPANY, INC.

Garden City, New York

Barbara Babcock Lassiter

—

AMERICAN WILDERNESS

The Hudson River School of Painting

of Painting

758.1

JACKET ILLUSTRATION: *SUNSET GLOW* by *Albert Bierstadt.*
Collection of Philbrook Art Center, Tulsa, Oklahoma.
FRONT ENDPAPER: *HOME IN THE WOODS* by *Thomas Cole.*
Courtesy, Reynolda House, Inc.
BACK ENDPAPER: *THE ANDES OF ECUADOR* by *Frederic*
Church. Courtesy, Reynolda House, Inc.

Designed by LAURENCE ALEXANDER

Library of Congress Cataloging in Publication Data

Lassiter, Barbara Babcock.
 American wilderness.
 1. Hudson River School. 2. Landscape painting,
American. 3. United States in art. I. Title.
ND1351.5.L37 758'.1'0973
ISBN: 0-385-08192-8 Trade
 0-385-04376-7 Prebound
Library of Congress Catalog Card Number 73-13089

Copyright © 1978 by Barbara Babcock Lassiter
ALL RIGHTS RESERVED
PRINTED IN THE UNITED STATES OF AMERICA
FIRST EDITION

C.2. 10/78 Col. State Lib. 6.00/9/74

To my son, Reynolds

Contents

CONTENTS

Introduction

Many members of the Hudson River School drew their original inspiration from the Hudson River and the nearby Catskill Mountains, but they did not restrict their painting to this one picturesque location. This group of landscape painters were passionate explorers and outdoorsmen who traveled to the most remote regions in search of new and striking scenery. At first, they ventured up the Hudson to the Catskills, then, north to the Adirondacks, east to the Berkshires and White Mountains. As the momentum grew, the more adventurous pursued the ever new as far south as the Andes and as far west as the Sierra Nevadas. They intermittently sought the spectacular in Europe or the exotic in the Middle East, but primarily the natural wonders of the New World caught their imagination.

However far from the Hudson River they had to roam, these artists returned in winter to their warm studios in the city at its mouth. In New York they found their best showplace and their liveliest patronage. As the city grew into the nation's greatest center of commerce, it also gave impetus to America's first native school of painting.

Thomas Cole's early paintings of the wild Catskill scenery mark the beginning of the Hudson River School in the year 1825. At that time there were no states beyond the Mississippi River. As explorers charted mountain heights and described strange rock formations in

the unmapped western territory, artists began to respond by celebrating natural beauty in their art. The promise of the wilderness kept the Hudson River School alive for over fifty years—the longest-lived period in American art history. When its popularity finally waned, the United States stretched to the Pacific Ocean, and the railroads had opened the once inaccessible regions of the Far West to settlement.

Such a large number of artists followed Cole up the Hudson River that by mid-century they were recognized as a "School," or a group of artists sharing the same beliefs. They agreed that their most vital efforts should be spent painting nature. They were not attracted to the ordinary kind of nature found in backyards; they sought out nature in its most wild and beautiful state. Consequently, the wilderness became a major theme of the Hudson River School.

Prior to the first decades of the nineteenth century, landscape painting was rare in this country. Portraits were the only kind of art that people would buy. Those artists who tried to paint historical themes failed, although history painting was the most fashionable branch of art in Europe. Americans wanted to create their own kind of painting. National leaders began to call for writers, poets, and artists to draw their vitality from their own great rivers, forests, and mountain ranges. At first, artists were uneasy about shedding the European modes of landscape painting, but the second generation felt confident that they were working as a truly national school fully supported and enthusiastically praised by the public and the press.

A world-wide movement called Romanticism reinforced the Hudson River artists' attitude toward nature. It started when people discarded reason and intellect in favor of emotion and intuition as valid means of finding truth. The Romanticists recognized that beautiful scenery elevated the feelings—particularly when it evoked solitude and awe. Being in the presence of nature became a spiritual necessity for nineteenth-century man. He believed that nature had the power to improve behavior, console the grieving, and bring peace of mind. Nature became the religion of many, and the forest became the church.

The Hudson River painters were incurable optimists who believed in the goodness of nature. They had to possess both stamina and faith to search out the highest waterfall or grandest view in an

unknown wilderness. They were hard-working, neat, dignified men who shared with their patrons the desire for status and money. They formed warm friendships with one another. They organized the first institution to promote the work of living American artists, and founded a still-thriving club for men interested in the arts. Their admiration for nature played an important role in promoting the land that was preserved for New York City's Central Park. The formation of the National Parks System was also a response to their success in awakening Americans to the beauty spots of their country.

Although history painting, portraits, still-life, and genre (painting of everyday life) occurred alongside the Hudson River School, the majority of artists turned their talents to landscape. Art organizations grew up all over the country to promote both landscape and genre painting. The enormous interest in the arts attracted the first commercial galleries to New York City. The first artists' studio building in the country was built to provide comfortable quarters for New York artists. Patrons shunned European art, preferring to purchase paintings produced by home-grown talent. The value of their work soared, and their large-scale landscapes brought the highest prices that had ever been paid for American painting.

These pioneer landscape painters came from a variety of backgrounds and studied art in a number of different ways. Whether they learned through trial and error, or acquired the techniques of the foreign academies, they professed that their true teacher was nature itself. They made detailed sketches outdoors, bringing them back to the studio where they were worked up into large, finished compositions. Sometimes they painted actual views, but their grandest themes combined the most characteristic elements of a region into a single panorama. They had reverence for the most obscure detail, and depended heavily on the novelty of their subject matter for originality. As the movement progressed they became more interested in light and air than any specific fact. No matter how brutal nature could be in reality, they chose in their paintings to reveal only its most majestic and awesome features.

The Hudson River School lasted as long as new scenery was being found. By the late 1870s exploration in the West had moved past the age of discovery. As the public grew tired of paintings of grand scenery, the huge canvases were crowded into attics, base-

ments, and storerooms. By 1900, the major talent of half a century of American art was forgotten.

Recently, their work has reappeared. Cleaned and dusted, relined and well lit, these sun-drenched landscapes once again hang proudly on the walls of our greatest museums. In the last decade, nearly all the leaders of the School have been given major exhibitions. Critics taking a fresh look at their work admire it today as the conscious effort of artists to create a native school. Their work preserves for us the joy they derived from the wonders of nature, and the look of the untamed wilderness as they knew it.

This story tells of the lives and work of only the leaders of this large and thriving movement. It has been a pleasure to explore with these men the natural beauty they portrayed with such loving care. They were born into a hopeful country in an optimistic time. Their unique way of seeing nature will never be repeated, but it is my hope that learning about their mission will give to our own age a greater love of nature.

American Wilderness

I

Thomas Cole's Boyhood

In the village of Bolton-le-Moor, Lancashire, England, young Thomas Cole whiled away the long evenings reading aloud travelers' accounts of America. His parents and seven sisters loved sitting around a glowing fire in their snug cottage listening to him read. Harriet liked to sit in the window seat looking through the little glass panes into the night. Annie chose the bench in the chimney corner where she could nudge the straying coals back into the crackling blaze with the toe of her boot. Sarah, the youngest, rested her head on her mother's knee. The other sisters huddled together on the thick, woolen carpet. Thomas, a frail youth with brown hair and blue eyes, leaned over a small book pushed close to the oil lamp. Mrs. Cole was also bent toward the light, occupied by her sewing, but attentive to the words of her son. Mr. Cole sank back into the pillow of a large chair. His eyelids flickered, not with oncoming sleep, but with dreams touched off by the vivid descriptions of the broad rivers, wild mountains, and rich woodlands of America.

There was an air of comfort and care about the old quarrystone

cottage. White curtains hung at the windows, crockery was arranged neatly on the mantelpiece, and a tall mahogany clock with a face painted on it stood like a guard at the door. There were objects in the room that suggested the family was one of some intellect and talent. Four or five books were stacked on a shelf. Paper, ink, and quill were ready for use on the desk, and some sheets of music had been tucked under a flute. Against one wall stood a quaint old pianoforte with a worn ivory keyboard.

Mr. Cole manufactured woolen goods, as did many who lived in Lancashire, the center of the textile industry in England. He longed to make a fortune, but he spent more time dreaming up new ideas than working out the practical details of the old ones. He wanted his only son to have the advantages of a formal education. He managed to scrape together enough money to send Thomas to a boarding school forty miles away in Chester. Thomas, who was born on February 1, 1801, was then only nine years old. He was a serious boy, but he was not able to study under the threatening whip of the brutal schoolmaster. He became so miserable and ill from cruel treatment and poor food that, after a few months, he was allowed to return home.

When he recovered, he was apprenticed to a calico designer. He spent long hours engraving designs on wood blocks. When these wood blocks were rolled with colored ink and pressed onto cotton cloth, they created the most beautiful patterns. Thomas liked the engraving, but disliked the uncouth boys with whom he worked. Having had a more refined upbringing, he felt set apart, and sensed that he was cut out for much higher goals than they were.

Many changes were taking place in the textile industry during these years. Mills in the district were converting to steam power. Men, women, and children who had once spun and woven cloth by hand in their homes, had to work at machines in large, noisy factories. They were beginning to rebel against low wages, long hours, and dangerous conditions. Riots and strikes began to break out.

The Coles, also, found themselves suffering from the upheavals of the industrial revolution. Mr. Cole's woolen trade was being swallowed up by fast-growing rivals. The thought of leaving this troubled region of England for the vast wilderness of America grew daily more appealing to the Cole family.

In the spring of 1818, Mr. and Mrs. Cole, Thomas, and his sisters set sail from Liverpool to Philadelphia. They brought with them enough cloth to set up a dry-goods shop. In order to supplement the small family income, Thomas continued engraving. Rather than going each day to the printer's shop, Thomas was allowed, for lower wages, to work on his engravings in the rear room of the family's store. But the shop was not as profitable as the Coles had expected. Having heard reports of better opportunities in the West, they decided to move to Steubenville, on the banks of the Ohio River.

Thomas stayed behind in Philadelphia, continuing his engraving. After a few months he received a letter from his parents saying that he was needed to engrave wallpaper designs for their new venture. Having no money for stagecoach fare, Thomas had to cross most of the state of Pennsylvania on foot. Accompanied by a friend, he set out on the dusty roads that wound through the foothills and over the Allegheny Mountains to Ohio. The two boys began their journey each morning before daybreak. As they passed the roadside cottages, they popped their heads through the oil paper windows to wish the startled sleepers a jolly good morning. By midday they walked along in warm sunshine singing songs and playing the flute; at night they stopped to sleep at a bustling inn or a snug farmhouse.

At Pittsburgh, they came to the beautiful Ohio River. Most early travelers took a raft, barge, or one of the new steamboats west from this point. Cole and his friend probably hopped a ride on a raft or barge from Pittsburgh down the river to Steubenville. The Ohio River was like a wide highway rolling through an immense wilderness. The forests were thick with deer, hare, wild hogs, and wild turkey. Some twenty years earlier the first settlers of Steubenville had to bar their doors against wolves and panthers. Now, the town boasted a pottery, woolen mill, and some small shops. On a hill in a grove of trees overlooking the river stood an impressive colonnaded mansion belonging to Bazaleel Wells, whose woolen mills were turning out the best broadcloth west of the Alleghenies. In town a brick courthouse dominated rows of wooden houses built flush with the muddy street. There, in the center of town, Thomas found his family happily lodged in their new home.

Thomas immediately joined his father in his wallpaper factory. He carved the wood blocks for printing wallpaper, and painted deco-

rations on specially treated muslin window shades that were popular at that time. People in town admired his beautiful designs.

The Coles had brought with them from England many of their prized belongings. Annie and Sarah played the piano, and Thomas often accompanied them on his flute. When the townsfolk heard the gay music, they often gathered outside the house to listen. The Coles had the only piano in town and many of the people had never heard one played. Thomas also spent long hours trudging through the surrounding wilderness—thriving on the close contact with the forests, the mountains, and the river.

After a few years, the Coles once again realized that their enterprise was not going to bring the riches they expected from the new world; the wallpaper was much too fine for most people in Ohio to afford. Customers were few, and the business did not prosper. Thomas began to look for other ways in which he could assist his family.

One day he met a portrait painter named Stein, newly arrived in town. Neglecting his own work, Thomas came every day to watch Stein grind colored minerals into powder, mix them with oil, and apply the creamy color to the canvas. Mr. and Mrs. Bazaleel Wells, who lived in the mansion on the hill, had commissioned him to paint their portraits. Stein painted them in a hard, flat manner typical of a self-taught artist of the time, but Thomas, nevertheless, was dazzled by the newcomer's painting techniques.

Thomas discovered among Stein's possessions the first book he had ever seen about great artists. He became so interested in it, he could not put it down. He imagined the glory that he could acquire as a great painter. His ambition was so aroused that he began the difficult task of teaching himself techniques that would transform him from craftsman to fine artist.

Portraits were the only kind of paintings for which Thomas could hope to find buyers in a region so recently a frontier. By making his own brushes and borrowing some oil paints from a chairmaker, he was able to train himself by painting members of his family. When, at last, he succeeded in catching their likenesses, he felt ready to find commissions. He packed his flute, paints, brushes, and a heavy grindstone. With the bag slung over his shoulder, he set out on foot to stir up trade in Ohio.

Traveling from town to town, he painted a saddler, an officer, a shopkeeper, and a captain—and for his labors he was rewarded with a saddle (although he had no horse), a silver watch, a chain and key, and a pair of shoes. Ohio was suffering from such a financial depression that Cole painted portraits for weeks before he received even a dollar.

The shy, sensitive Cole did not like painting portraits. He was terrified of his sitters. He felt more relaxed and painted more freely if they happened to fall asleep. Not being able to make much of a living at it either, he finally returned home. His parents were having their troubles, too. Their wallpaper business was losing money, and they had decided to move eastward, to Pittsburgh, hoping to find greater opportunity in a larger town. Cole, once again, stayed behind to continue painting in Steubenville. His endeavors were suddenly put to an end when some vandals broke into his rooms, tore up his canvases, and destroyed his brushes and paints.

The discouraged young man now strolled off into the wilderness to ponder his future: Was he meant to be an artist? Could he succeed? Maybe nature could provide the answer. He placed a pebble on the top of a stick; then with another pebble held in his fingers, he stepped back. "If I knock it off," he told himself, "I will pursue my career as an artist to the bitter end. If not, I will give it up." He aimed carefully, and tossed the pebble; it hit the other, knocking it off.

Steubenville was clearly not a profitable place to practice the arts, so Cole retraced his steps, stopping in Pittsburgh to help his family with their latest venture—manufacturing carpets.

In his spare time Cole turned to the fields and forests outside of Pittsburgh to find consolation. Nervous and uncomfortable in the company of other people, he sought from the shapes and movement of trees, rocks, and streams, an expression of his own emotions. He wondered whether he could transmit the feelings that nature evoked in him to his drawings and he brought his sketchbook into the woods. When he began to draw nature's shapes, something magic happened to his sketches; his pen delineated the gnarled and twisted trees so freely that they seemed to be alive.

Now, hoping to re-establish his painting career in the East, he walked all the way back from Pittsburgh to Philadelphia. He carried with him a small trunk and six dollars. As meager protection from the

cold November wind, he clutched a tablecloth around his shoulders —the only wrap his mother could give him. In Philadelphia he found lodging in the upper room of a house owned by a poor family. There was neither a bed nor a fireplace. His tablecloth served as an overcoat by day, a blanket by night. But he worked hard.

The commissions that were offered to Cole by Philadelphia businessmen were far removed from the kind of art that he hoped would bring him fame. They wanted comic scenes for oyster houses and drinking scenes for bars. Relatives of the deceased wanted portraits painted before the bodies were buried. Driven by necessity to take on any work that was offered, Cole once had to spend days painting the portrait of a corpse.

At the Pennsylvania Academy of Fine Arts, which had been established in 1805, Cole had the opportunity to study the works of other artists. Among the plaster casts of antique statues, copies of European masters, portraits, and historical paintings, Cole noticed some small American landscapes by a local artist, Thomas Doughty. Doughty, an early landscape painter, had been able to convey in his work only a glimmer of his experience of American nature, but Cole's sensitive eye recognized this early artistic awakening to the land, and he became inspired to devote his efforts toward painting the scenery of his adopted country.

II

Cole Discovered

With a new vision of how nature should be depicted in painting, Thomas Cole left Philadelphia to join his family in New York, where they had settled after another business failure in Pittsburgh.

Once a small town perched on the tip of Manhattan Island, New York had been growing rapidly for a number of years. Lower Manhattan was crowded with three- and four-story-high buildings topped here and there by domes, cupolas, and slender church steeples. Grand houses looked out over the harbor from the Battery at the south end. Broadway, the principal street, was lined with stores of all kinds—bookstores, milliners, silversmiths, print shops, and coffee houses. Large signs on taverns and hotels welcomed visitors. Hackney coaches and private carriages rattled down the street among push-carts, oyster wagons, wheelbarrows and even scavenging dogs and pigs. At night rusty oil lamps sent a spotty glow on the brick sidewalks. A few miles north along Broadway the bustle subsided and the pavement tapered off into a dirt road that ran through Greenwich Village. Pastures, orchards, and woods covered the rest of the island.

At the time of Cole's arrival, public excitement was building up over the opening of the Erie Canal. After eight years of digging across the entire state of New York from Buffalo on Lake Erie to Albany on the Hudson River, the Erie Canal was finally completed. In October 1825, Governor De Witt Clinton took the first voyage through the newly completed canal and down the Hudson River to New York City. Throughout the eight-day journey on the canal boat *The Seneca Chief*, he was greeted from the shore with roaring cannons, ringing bells, and cheering crowds.

Frigates and barges flying colorful banners awaited his arrival in New York Harbor. The governor celebrated the completion of his voyage by pouring a keg of Lake Erie water into the Atlantic Ocean. The two bodies of water were now joined. After the ceremony throngs of people paraded through the streets and bright rockets tore through the night sky. Now that produce could be sent safely and cheaply from farms in the Midwest by way of the canal, New York City was assured of great prosperity.

For many years reports of the scenic beauty concealed in the mountains that sloped into the western banks of the upper Hudson had caused excitement among New Yorkers. From the day Cole first glanced up the Hudson to the distant cliffs of the Palisades, he had hoped to travel farther up the river to explore the very heart of the Catskill Mountains. A New York merchant, George W. Bruen, who had admired some of Cole's studio paintings, believed that he should try his skill on the natural beauty of New York State. He offered to pay Cole's steamboat fare and the young artist happily set off for this wilderness region.

Cole spent weeks exploring and sketching the Catskills. He struggled to record in his sketchbook the exact shape of the hills and mountains. Every detail of this beautiful wilderness was to be faithfully rendered—the woodland debris, the strewn rocks, the knotted underbrush. Organizing the tangled growth into a pleasing composition was not an easy task. It challenged the artist's skill to the utmost.

Laden with sketchbooks, Cole returned to his attic room on Greenwich Street. Despite the small quarters and dim light, he managed to work up his sketches into three finished oil paintings. He took them to a frame shop on Broadway and persuaded the owner to place them in his window. At first they drew little attention.

Passersby merely paused, glanced at the canvases, and hastened on their way. But the novelty of these wilderness scenes brought Colonel John Trumbull, the president of the American Academy of Fine Arts, to a halt. He peered intently through the glass. He did not need to read the titles to recognize the wild and lonely beauty of the Catskill Mountains.

The old Revolutionary War colonel was at that time the most influential man in New York art circles. He had long sought an artistic expression for his young country. Congress had commissioned him to paint historic scenes from the Revolution that had been installed in the rotunda of the new Capitol in Washington, but these grand subjects had not fired the imagination of the general public. The country was moving ahead too quickly to dote on the past. American hopes were based on the future; in building a new nation from the endless forests, nameless rivers, and uncharted plains. The American dream lay in the wilderness. It had inspired this unknown genius to compose landscapes unlike any Trumbull had ever seen and to imbue them with an exaltation that awakened a new emotion in the old man.

Colonel Trumbull entered the shop and purchased a painting entitled "Kaaterskill Falls." With his find carefully wrapped under his arm, he rushed into the bitter November air. He hurried along the sidewalk until he arrived at the painting rooms of artist and art critic of the New York *Mirror*, William Dunlap. Trumbull pulled Dunlap over to the window, unwrapped the painting, and held it at arm's length under the light. Dunlap squinted his one good eye. He saw a scene taken from inside a cave behind a waterfall. Broken branches were caught among the rocks in midstream. Thick and twisted bushes edged the banks. Then, the plunging water disappeared over a ledge. Dunlap had never seen such a daring view.

As the two older artists examined the painting, Asher B. Durand, a young engraver, dropped by. He was surprised to see the crotchety old colonel in such good spirits. Durand took a look at the landscape and agreed that never had he seen one that caught the wildness of the Catskills so expertly.

Before Durand had a chance to remove his overcoat, Trumbull was leading Dunlap and himself by the arm down Broadway to see the two paintings remaining in the shop window. Dunlap bought

9

"Catskill Lake" and Durand bought "A View of Fort Putnam" (on the Hudson). Both artist and engraver agreed that Trumbull had discovered a genius.

Asher B. Durand also owed his recognition to the kindhearted but arrogant colonel. Born on August 21, 1796, Asher had spent his entire boyhood on a farm in Jefferson Village (now Maplewood), New Jersey. He was the sixth son of an industrious father of French Huguenot descent, and an affectionate mother of Dutch descent. His ancestors on both sides of the family had arrived in this country as early as the seventeenth century. With five robust brothers tending to the farm chores, the more frail Asher helped his father engrave monograms on the backs of watches. On the occasions when an itinerant teacher came to the village, he was allowed to leave his father's shop to attend school.

When he was fifteen years old, he left Jefferson Village to apply for an apprenticeship to an engraver in New York City. He found that he needed to pay a thousand-dollar fee—too high for his father to afford. He persisted in his search for work, and was finally accepted on better terms by Peter Maverick, a prominent writing engraver, who worked just outside of Newark, New Jersey. After five years of apprenticeship, Durand had become so skilled that he was invited to become a full partner. In October 1817, Maverick sent Durand to New York to open an office on the corner of Pine and Broadway.

At that time Colonel Trumbull had been trying to sell advance orders for engravings of his oil painting "The Signing of the Declaration of Independence." He wanted to hire a top English engraver to do the work. He did not, however, receive enough advance orders to afford the high price of a foreign engraver, so he was forced to look for the best craftsmanship available in his own country. He had noticed the fine quality of Durand's engraving, and offered the commission to him at a lower rate.

Durand accepted the offer of three thousand dollars and set to work for the following three years on the large and complicated engraving. It was not an easy task to produce the effect of an oil painting with black lines and dots, nor to engrave the faces of the forty-seven signers so that each would be recognizable, but the final

LAKE WITH DEAD TREES (CATSKILL LAKE) by *Thomas Cole. Allen Memorial Art Museum, Oberlin College.*

outcome was so superb that Durand became known as the finest engraver that America had ever produced.

Durand had acquired this position of prestige just two years before Cole's arrival in New York City. Now, the handsome twenty-nine-year-old engraver, with thick dark hair and rich brown eyes, waited in the frame shop with the two gray-haired artists for the name and address of the painter with whom he was to establish a deep and lasting friendship.

Durand offered to walk over to Greenwich Street to invite the artist to Trumbull's painting rooms. He returned accompanied by a delicately built young man with a pale face brightened by red cheeks. His clothes were threadbare, and his coat barely suitable for the weather. Thomas Cole stood before the two leaders of the art world like a schoolboy in the presence of the principal. Cole did not know why he had been called to the painting rooms of the president of the American Academy of Fine Arts. He did not know why these men asked so many questions. His hands moved nervously and his voice at times faltered. Finally the gruff colonel brought out Cole's painting, smiled and said, "You surprise me, at your age, to paint like this. You have already done what I, with all my years and experience, am yet unable to do." Cole had often imagined that such praise would some day come to him, but now that it occurred, he blushed with embarrassment.

The mere handful of men interested in their country's artists were well known to Trumbull. He quickly scribbled off letters to collectors in other eastern cities, urging them to see Cole's work on their next trip to New York. His nephew-in-law, Daniel Wadsworth of Hartford, Connecticut, liked the painting "Kaaterskill Falls" so much he commissioned Cole to paint a copy of it for him. Philip Hone, the diarist and mayor of New York, offered Dunlap fifty dollars for "Catskill Lake"—twice what Dunlap had paid for it. Feeling guilty over pocketing the profit himself, he made up for it by writing glowing reviews of Cole's paintings for the New York *Mirror* and other newspapers of the day. From then on Cole's fame spread rapidly, and the Hudson River School was launched.

III

A New Academy

These were encouraging beginnings, but the interest in art in New York City of 1825 could not compare with that in the great art centers of Europe. There were no art galleries or museums devoted to encouraging American art, nor were there any formal schools where young artists could acquire training. There was only the American Academy of Fine Arts—a poorly managed institution ruled by the whim of Colonel Trumbull.

Organized in 1802, the American Academy of Fine Arts had struggled from lack of funds during its first years. In 1816, it reopened in renovated galleries in the old Alms House on Broadway and Chambers Street near City Hall. Some paintings by the American masters Benjamin West and Gilbert Stuart had been borrowed for the occasion, but its permanent collection consisted mostly of copies of European paintings and plaster casts of Greek and Roman statues. There were no artists on the board of trustees. It was composed of statesmen, bankers, merchants and physicians. They ran their institution according to eighteenth-century classical traditions,

believing that a sound education in art required the study of models of ancient statuary and European old masters. After De Witt Clinton, who later became governor of the state, resigned from the presidency, the board turned the institution over to John Trumbull. They believed that under the guidance of the leading historical painter in the country, the American Academy would zealously serve the city's professional artists.

In the first quarter of the nineteenth century, most artists still hoped to become painters of historical scenes. These paintings were filled with figures in a variety of poses acting out an event of history. In order to learn to draw and paint figures, the artist studied the sculpture which embodied the most perfect human proportions—that of ancient Greece and Rome. The only collection of plaster casts available for study in the city was owned by the American Academy.

In response to the demand from a growing number of young artists in New York, the American Academy had reluctantly agreed to open its galleries to students, from six until nine in the morning. They worked in the gallery of statues—an unheated room which Dunlap humorously called the "saloon of the antique." The artists had to rise before daybreak, make their way through dark streets, and wait at the academy door until it was unlocked. Sometimes they could hear the old doorkeeper puttering around inside, but if the impatient students pounded on the door, he would shout insults at them. The doors were opened only when it suited the stubborn doorkeeper.

The unhappy students appealed to the academy president, but Trumbull's generosity vanished when his authority was challenged. In response to their complaints, he announced bitterly: "When I commenced my study of painting, there were no casts to be found in the country. I was obliged to do as well as I could." He reminded the students that the board of directors had gone to great expense to import the plaster casts. They had no title to them, and no say about how and when they were to be used. Memories of his own hardships began to rise in the colonel's mind, and he blurted out, "You must remember that beggars are not choosers." His final statement touched off a revolt against his academy.

Samuel F. B. Morse, a talented thirty-four-year-old painter and later inventor of the telegraph, heard of the plight of the young artists. He invited them to his painting rooms where they discussed their

problems over fresh strawberries and cream. He offered to help them establish their own drawing association. It was to be called the New York Drawing Society. At the first meeting, Durand, Cole, and nearly thirty other artists appeared. They agreed to bring their own materials and to pay five dollars in dues. Morse was unanimously elected president.

The New York Drawing Society met three times a week in the evenings in a room provided rent free at the New York Historical and Philosophical Society. In times before electricity and before the widespread use of gas, artists had difficulty working at night. In order to light the plaster casts of ancient sculpture borrowed from the American Academy, the artists erected a post ten feet high. On top of it they placed a can containing 12½ gallons of oil and a wick four inches in diameter. This gave off enough light to illuminate the models, and each artist brought his own oil lamp to light his paper. These meetings were well attended and the artists now thought they were free from the tyrannical Trumbull.

About a month after the Drawing Society was formed, an unexpected visitor entered the smoky art room. The artists were bent over their work, and did not notice that Colonel Trumbull had made his way through the shadows. When Trumbull had learned about the frequent meetings of the association, he had felt slighted. He now intended to bring the artists back under his control. He stationed himself in the front of the room. In a loud, commanding voice he insisted that each member of the Drawing Society register as a student of the American Academy. He placed his large, leatherbound registration book on a table, opened a bottle of ink, and held out a quill. Not one of the students rose to sign his name. The disgruntled colonel shrugged his shoulders, and marched out of the room, leaving the book behind.

The Drawing Society hastily returned the borrowed plaster casts and organized meetings to discuss their relationship to the American Academy. They not only needed their own place to draw, but they also needed their own place to exhibit their work. They questioned whether there was enough interest in art in New York to support two academies. Before they broke all ties with the old institution, they decided to make a final attempt to convince the American Academy to accept their demands. They hoped to persuade Trum-

bull to appoint artists from their group to his board of trustees. President Morse, Dunlap, and Durand volunteered to meet with him. Trumbull would have none of it. He rejected their plea with ironic words: "Artists are unfit to manage an Academy. They are always quarreling." A description that befit the testy colonel more than the younger men.

After this humiliating rejection, the young artists now resolved to organize a new academy. They met on January 14, 1826. Still under the leadership of Samuel F. B. Morse, the new association, called the National Academy of Design, became the first institution in the United States governed solely by artists and devoted entirely to the exhibition of contemporary American art.

Asher B. Durand had taken a leading role in the formation of the new academy. Thomas Cole was also caught up in the young artists' rebellion. Both were listed as founding members, and helped organize its first exhibition. Durand pounded the streets to find a large room for rent, and Cole ransacked the artists' studios to find enough works of art to fill it.

Four months later Governor De Witt Clinton, the mayor, public officials, the faculty of Columbia College, and fashionable members of society arrived at a private opening in a rented house at the corner of Broadway and Reade Street. They walked up one flight of steps and entered a long room dimly lit by three double gas jets. The guests were greeted by members of the new academy—dashing young artists wearing white rosettes in their buttonholes. One hundred and seventy works were being shown—original oil paintings, watercolors, engravings, and even architectural drawings—but they were all by living American artists. The National Academy had succeeded in putting together a stunning display of talent.

From that time on, the National Academy held exhibitions each spring. The first year they had not been able to meet their expenses collecting only three hundred dollars in admission fees. But attendance continued to grow, and two years later admission fees had nearly tripled. Lighting was improved and the galleries were kept open in the evening so that merchants and professional men could attend the exhibitions after work—a novel idea that was so popular that twice as many people came in the evenings. Collections began to be formed by people who had never before purchased a work of art.

IV

Catskills and Sermons

The budding energy of New York artists had been matched some years earlier by New York's first writers. Many travelers had written descriptions of American scenery, but none had brought to it the force that arose from the pens of Washington Irving and James Fenimore Cooper. People had first become excited about the wild beauty of the Hudson River region when they read Irving's vivid descriptions of the glens and hollows that provided the setting for Rip Van Winkle's forty-year nap. James Fenimore Cooper spun his early plots through the back-country scenery of Otsego Lake—some sixty-five miles northwest of Rip Van Winkle country. These writers drew the attention of Americans to the picturesque scenery of the little-known New York State wilderness.

Believing in the wilderness as a valuable subject, artists and writers associated closely with each other in the 1820s. The most sociable of the writers, the somewhat overbearing James Fenimore Cooper, gathered the leading talent of New York together once a week at the sumptuous City Hotel, which occupied an entire block.

Under his leadership, writers became acquainted with artists such as Dunlap, Morse, Durand, and Cole. Lawyers, merchants, physicians, and professors from Columbia College were also invited to join this famed group. Their menu reflected Cooper's extravagant tastes. They lunched lavishly on stewed oysters, kidney pudding, pastries, wine, and other dishes found on the bountiful menu of New York's finest hotel. These meetings were called "The Bread and Cheese Club" because the bread and cheese were used as ballots: the bread being a vote for membership, and the cheese being a vote against.

No cubes of cheese were found on the platter when poet and editor William Cullen Bryant was proposed for membership. He was unanimously accepted into the club and was to remain the most loyal supporter of the artists throughout his lifetime. He had stunned the public in 1821 with descriptions of the beauty of the American wilderness in his famous poem, *Thanatopsis*. When he arrived in New York as apprentice on the *Evening Post*, he was quick to learn of Cole's celebrated paintings, and remarked that the interest that they aroused was like the interest awakened by some great discovery. Although Cole made a somber figure among the sparkling wits that graced Cooper's luncheons, Bryant, also a newcomer to New York, and equally shy and modest, took a liking to the sullen artist. Bryant wrote poems describing many of the Catskill haunts that Cole depicted in his paintings, and their mutual response to nature created a lasting friendship.

For a time, the impact of these brilliant men and the newness of American scenery kept Cole's attention drawn exclusively toward painting American nature. He returned each summer to Catskill Village, from where he had easy access into his favorite region of the Catskills. He enjoyed climbing up peaks to catch the last rays of a sunset, and hiking through the thick brambles to reach a secret waterfall. He sought out rock caves during thunderstorms, and from their dark shelter he imagined at every burst of thunder, trees crashing to the ground and rocks loosening from the mountainside. In nature's gentler moments he observed the affection of intertwined trees and the sadness of drooping willow branches. Toward nature he felt the passion of a lover, but the love of nature never waned and its pleasure never brought remorse.

Cole's spiritual needs were also satisfied by nature. When he en-

tered the forests, he felt at peace with himself. All his worldly troubles seemed to vanish. The wild, uncultivated beauty of America made Cole feel as though he were a better man.

Cole carried his sketchbook on these summer excursions. Although still fairly small in size and tightly rendered, his paintings reveal an artist developing his skill to convey his love of nature. He painted scenes of Kaaterskill Falls, Haines Falls, and the Cloves or deep gorges of the Catskills. He painted the wild scenery in all kinds of weather: during violent storms and on quiet sunny days, at sunrise and sunset. He caught the brilliance of the forest best just after a storm had broken and the sunbeams burst through the dark clouds.

Sometimes Cole identified himself so intensely with nature that his painted trees and rocks take on a human quality. The splintered lightning-struck stump so often used in the foreground of his paintings appeared to be an agonized gesture of Cole himself. The people of his time, however, saw in his scenery, not a mirror of Cole, but a true representation of their own land skillfully rendered for the first time in oil paintings. They saw in his landscapes the exact form, color, and atmosphere of American scenery which aroused a strong nationalistic response. Philip Hone remarked that he proved his love of country by owning a painting by Cole. Art critics also liked their American flavor. One of them wrote: "The boldness of the scenery itself, the autumnal tints which are spread over the forest, and the wild appearance of the heavens, give it a character and stamp that we never see in the works of foreign schools . . ."

So loved were these landscapes that they were bought by collectors from Boston, Hartford, Philadelphia, Baltimore, as well as New York. One of Cole's most influential patrons was a merchant from Baltimore by the name of Robert Gilmor. Gilmor liked the paintings by Cole that reminded him of the scenery he had seen during his walks in the mountains. He often suggested the subjects that he wanted Cole to paint for him. When he requested Cole to enliven a landscape with a scene from one of Cooper's novels, Cole made a special trip to Lake George in upper New York State, the setting of Cooper's recently published *The Last of the Mohicans*. Although Cole made numerous sketches of the area, the completed landscape appears to be an imaginary scene rather than a familiar Lake George setting. On receiving the painting, Gilmor, who was careful to praise

THE LAST OF THE MOHICANS by Thomas Cole. Courtesy New York State Historical Association, Cooperstown.

as well as criticize, liked the atmospheric blue of the distant lake, but found the shape of the rocks artificial and the arrangement of them forced. He told Cole that the toppled boulders he had painted were not ordinarily seen in nature. Cole had so highly dramatized the local scenery that it held little resemblance to the Adirondack region. Seeing no hint of his own country in the setting disappointed Gilmor.

In defense of his painting Cole wrote to Gilmor that the great landscapes of the past had been based more on imagination than reality. Gilmor agreed, but he thought that when natural elements were not taken directly from nature, they became repetitive and monotonous. A self-taught artist such as Cole was not experienced enough to attempt imaginative landscape without its appearing artificial. Cole should stick to real American scenes.

Gilmor's words came as a challenge to Cole. Cole wanted to show that he could compete with the best artists of all time. He decided to embark upon an entirely imaginary work. Rather than choosing a landscape or another theme from contemporary literature, he chose a subject of unquestioned significance, "The Expulsion of Adam and Eve from the Garden of Eden."

In the final painting Cole placed two tiny figures of Adam and Eve in the midst of a dark and fearful landscape. In the distance a volcano erupts, a fierce wind bends the palms, torrents of rain pour from swirling clouds, and a jackal eats a mangled deer on a path leading out from the high rock arch that forms the Gates of Paradise. Behind the Gates, Cole presented a glimpse of the soft meadows, golden rocks, and flowering gardens of Eden from which the pair have been banished. Cole hoped that his painting would teach people that they must turn away from their destructive patterns.

He placed a high price on this painting and expected to sell it quickly to Gilmor. Although the painting was beautiful and wildly romantic, it had nothing to do with the American scenery that Gilmor loved. He tactfully assured Cole that he should certainly be able to sell the painting in New York City where there were so many rich and thriving men. "I am literally overstocked with pictures," he wrote Cole apologetically. "I have some of my finest lying around the house like lumber for want of room to hang them up."

Cole, who had had such high hopes for this biblical landscape, was crushed. His principal patron having turned it down, he sent it to the

EXPULSION FROM THE GARDEN OF EDEN by Thomas Cole. Courtesy Museum of Fine Arts, Boston. M. and M. Karolik Collection.

National Academy Exhibition of 1828 and afterward to Boston, but it remained unsold. On Gilmor's advice, Cole decided to raffle it off—a common practice of the times. He tried to sell chances at twenty dollars each, but he was unable to find enough buyers to bring the four hundred dollars he expected. Humiliated at his failure, Cole had to return the money to the few people who had bought chances on the painting.

One day he ran into the wealthy botanist and physician Dr. David Hosack. Hosack inquired about Cole's painting "The Expulsion," which he had seen at the National Academy Exhibition. When he discovered that it had not yet been sold, he grew interested. The portly physician had been a founder and staunch supporter of the old American Academy. A biblical scene with a moral to it appealed to his old-fashioned taste. Cole offered it to him at a lower price, and he agreed to purchase it. With money in his pocket, Cole now began to consider making a trip to Europe.

V

A European Tour

News of Cole's proposed trip to Europe spread concern among his friends. They had previously grown worried over the direction that his art seemed to be taking. "The Expulsion of Adam and Eve" had appeared to be influenced by European tradition. Had they lost their first painter of "truly American scenes," before he had matured? America's two best writers had become entranced with Europe. Irving, who had left the United States many years earlier, was still reveling in the splendor of Spain. Cooper had recently packed up his family to enjoy the honors that his European readers were bestowing on him. Now, word spread that America's first landscape painter was departing.

William Cullen Bryant, now promoted to editor of the *Evening Post*, was so distraught over the direction that Cole seemed to be taking that he wrote a sonnet entitled, *To Cole, the Painter, Departing for Europe*. He warned Cole not to become so inspired by European scenery that he forget the beauty of the United States. He wrote:

Fair scenes shall greet thee where thou goest—fair
But different—everywhere the trace of men.
Paths, homes, graves, ruins, from the lowest glen
To where life shrinks from the fierce Alpine air.
Gaze on them, till the tears shall dim thy sight,
But keep that earlier, wilder image bright.

To allay the fears of his friends, Cole decided before he departed for Europe to take a quick trip to the grandest of American spectacles—Niagara Falls. "I shall endeavor to impress its features so sharply on my mind," he wrote to Gilmor reassuringly, "that in the midst of the fine scenery of other countries its grand and beautiful peculiarities shall not be erased."

Americans had long been dependent on England for their art education. Trumbull, Dunlap, and many artists of their generation had studied at one time or another in the London studio of the American-born Benjamin West. They learned how to paint portraits and the elaborate historical paintings for which West was famous. Their aim was to acquire styles that equaled those of the famed English artists. Now that the United States had won its independence, artists hoped to develop their own national style. Younger artists no longer traveled abroad to copy European paintings, but to examine their technique with the intention of applying it to their own subjects and theories. Without any painting tradition of their own, however, the first generation of landscape painters arrived home more influenced by European concepts than they were willing to admit.

In June 1829, Thomas Cole sailed for England. Although the ocean was calm, he suffered from seasickness during most of the four-week voyage. The sight of the rich green English coastline came to him as a relief. After eleven years in the United States, the twenty-eight-year-old artist felt like a stranger in England.

Now that Cole was to see for the first time paintings by the famed English artists, he dreaded the prospect. He had been haunted by the possibility that he had come to Europe in order to overcome his own deficiency as an artist. Would his work measure up to the paintings of the famous artists on exhibition at the Royal Academy? Founded by King George III in the eighteenth century, it was the

oldest and most important art institution in England. The famous portrait painter Sir Thomas Lawrence was then serving as president, and the two most talked-about members were the landscape painters John Constable and Joseph Mallord William Turner. Cole entered trembling with fear. After he looked carefully about him at the heavily gold-framed works of art, he grew relieved. Most of the work did not come up to his expectations. He liked Turner's "Ulysses Deriding Polyphemus," a theme from Homer's *Odyssey*, but on the whole, he thought that most of the artists produced "washy imitations." He decided that his work compared favorably with his English contemporaries, and was pleased with himself for achieving so much without the aid of the great academies of Europe.

With renewed confidence in his own ability, Cole worked long and hard in his London studio, producing mostly American scenes for English collectors. He sent one of his paintings to Cooper's friend, the famous poet and patron of the arts Samuel Rogers, who was well-known for the help that he gave to young artists. Rogers returned the favor by inviting Cole to dine with him at his famous house on St. James Place. A letter of introduction from Robert Gilmor introduced Cole to Sir Thomas Lawrence. They chatted over a breakfast of boiled eggs and tea about the future of American art. When the elderly Lawrence died the following year, Cole lost a valuable friend.

During most of the time he spent in London, Cole was lonely. He missed the warmth and companionship of his close family circle. He complained of passing weeks in his studio without a single visit from an English artist. "I found myself a nameless, noteless, individual in the midst of an immense selfish multitude," he wrote to Dunlap. Charles Robert Leslie, an American artist and author of John Constable's biography, sometimes dropped in for a chat, but Cole had difficulty appreciating this friendly gesture when he was so keenly aware that Leslie did not think there was any merit in his painting. The gloomy climate increased his misery, and he slipped into one of his recurring moods of despair.

He continued to paint, and his work was accepted at both the Royal Academy and its rival, the British Institution—the two finest exhibitions in London. In those days paintings were hung on the

walls from the baseboard to the cornice, and the lighting of the rooms was glaring and uneven. Paintings of academy members were given the privileged places. When Cole arrived at the exhibition, he was dismayed to find his paintings hung in the dark, obscure places. John Constable tried to console him by admitting that his paintings had also been hung in the worst places. Cole had better luck, however, at the newly founded Gallery of the Society of Artists, a group sympathetic to landscape painters. In its well-lit galleries, his painting "Tornado in an American Forest" was sought out by the English press to be favorably reviewed in a number of newspapers.

One popular place to visit in London was the private gallery of Joseph Turner. He had built it as an extension of his house in order to display his paintings. When Cole arrived at Turner's house and gallery, a doddering old housekeeper opened the great front door. He entered a vestibule lined with casts of ancient statuary. As he proceeded down the dingy hallway, tailless Manx cats leapt out of rooms stacked with unfinished canvases and, like a disorderly army, escorted him into the gallery. It was ablaze with light and color. Turner's golden paintings were hung frame-to-frame against Indian red drapery. Some paintings had been left propped up against the walls. Turner had taken great care in lighting his paintings. He had hung netting above the cornice from one end of the room to the other, and had laid sheets of tissue paper on it. The paper diffused the brilliant light from the skylight, spreading it evenly all over the room.

As Cole studied the paintings, Turner walked out from behind a shabby screen. He was an undersized man with a beakish nose, ruffled hair, and coattails that nearly reached the floor. He held himself up so straight that he seemed to lean backward. When he shook Cole's hand, he merely said, "Hmph-humph," and nodded. Cole was surprised by his lack of refinement, but his good nature soon overcame his coarse manners and thick speech.

One of Turner's great historical paintings, based on Dido, the legendary founder and queen of the ancient city of Carthage, hung in his gallery. Turner thought so much of this work that he willed it to the National Gallery under the condition that they agree to hang it next to the work of the famed seventeenth-century landscape painter Claude Lorrain. Cole admired "Dido Building Carthage" profoundly. It showed a classical city being constructed around a harbor. All the

waterfront activity was painted with great care. Cole studied the innumerable details. In a second painting Turner had depicted the "Decline of Carthage." The rise and fall of a civilization was a popular theme of the time, and Turner's method of treating it was of intense interest to Cole.

Turner had painted "Dido Building Carthage" fifteen years earlier—in a more realistic style than he was then employing. When Cole met him, he was experimenting with the effects of paint for its own sake, describing atmosphere and light rather than detailed subjects. In many of his paintings forms and shapes had been dissolved in ochres, umbers, yellows, and whites. These experiments in the effects of light made Turner a forerunner of Impressionism—the French school of art that arose later in the century.

Cole was deeply offended by Turner's recent paintings. He felt that the artist was too involved with the management of paint, and not interested enough in content. He wrote home that Turner's current paintings were the strangest things imaginable: "All appears transparent and soft, and reminds one of jellies and confections." He criticized the English for their mania for what they called generalizing. He believed that generalizing was an excuse for lazy artists not completing their paintings. They were "full of sound and fury signifying nothing."

During the time that Cole was in London, Turner was creating a spectacle on varnishing days at the Royal Academy. Five days before the opening of the exhibitions, academy members were given the opportunity to touch up and varnish their paintings after they were hung in place. Varnishing days were becoming highly competitive as artists began to use them to improve their painting in order to outdo the one next to it. Turner was in the habit of sending in unfinished canvases which he completed, and sometimes nearly entirely painted, after they were hung on the academy walls. His painting methods were so unusual that artists gathered around to watch him paint. The wizened Turner was quite a spectacle standing on a bench in a tall beaver hat with pots and cups of paint at his feet. The artists watched curiously as he spread layers of thin color over parts of his canvas with stubby brushes and rolled half-transparent lumps of paint into position with his palette knife. As if by magic the image would suddenly emerge, and Turner would pick up his tools and, without a

word, walk away leaving his spectators wondering how such unruly methods could create such beauty.

At the National Gallery, Cole had his first opportunity to study genuine Old Masters. The collection, today one of the world's largest and finest, then consisted of only thirty-eight paintings by such famous artists as Rembrandt, Titian, Velasquez, Claude Lorrain, and Poussin. The government had recently purchased the collection and permanently exhibited it free of charge in a house in the Pall Mall district of London. The painters that Cole liked best were the seventeenth-century landscape painters Claude Lorrain and Gaspard Poussin. He did not set up his easel in the galleries to copy the paintings, which was the common practice of many artists. He feared he might lose his originality if he did so.

In May 1831, Cole left London for Paris. The gallery of the Louvre contained one of the largest free exhibitions of masterpieces. But when Cole arrived there, he was disappointed to find that the walls were not hung with the great Old Masters, but with the work of contemporary French painters. "I was disgusted with their subjects," he wrote. "Battle, murder and death. Venuses and Psyches, the bloody and the voluptuous, are things in which they seem to delight. They too seem artificial, laboured and theatrical."

Cole left Paris quickly. By the end of May, he was sailing down the Rhone River to Marseilles, and catching a steamboat from there to Leghorn, Italy. He proceeded by land to Florence and rented a room there in the same house with the American sculptor Horatio Greenough. After two years in gloomy England, sunny Italy did not immediately cheer him. He realized that he could no longer respond to nature, as he had in his early years. He worried that the romantic feeling had passed forever. His sense of the beautiful had been deadened, his emotions were numb. In such a mood he "looked upon the beautiful scenery, and knew it to be beautiful, but did not feel it so." This time Cole did not blame his unhappiness on his loneliness, but on his having been in public too much. He needed more time alone.

By autumn his melancholy had passed, and Cole responded happily to the beauty of the Italian countryside. Although he adored the galleries of Florence, he did not copy any of the paintings there either. He painted actual views of the city, the Arno River, and the

surrounding countryside. He loved the softness of the Italian skies and the gorgeous twilights, but remembering the warnings from home, he assured his American patrons that he had seen "no scenery yet which affected him so powerfully as the wilderness places of America."

Leaving Florence, Cole settled in Rome in the former studio of Claude Lorrain at the top of the Spanish Steps. Rome was then the artistic capital of the mid-nineteenth century, just as Paris would become at the end of the century. Artists of the Romantic Period relished the old buildings and classical ruins that inspired them to think of long past heroic deeds enacted on that ground.

As Cole gazed upon the ruins of the Roman Colosseum in the moonlight, he imagined the spectacles that once occurred within the now crumbled walls. He was reminded of Turner's "Building" and "Decline of Carthage" and thought of the lesson to be learned from the changes that had taken place over that period of time. He began to jot down detailed descriptions of compositions depicting the rise and fall of an empire.

As Cole contemplated this grand theme, he learned of the cholera epidemic in New York. Fearing for the health of his parents and sisters, he decided to return home.

VI

A New Patron

After seven tiresome weeks on board ship, Cole arrived in New York Harbor. The cholera epidemic had subsided, and he found his family in good health. He rented painting rooms on the corner of Wall Street and Broadway, and proceeded to unpack his belongings and European sketches. When Friday came, he searched through the newspapers for initials that designated where the Sketch Club was to meet. Finally he found "S.C.–S.F.B.M." in the lower left-hand corner of the *Evening Post*. The initials informed him that the Sketch Club would be meeting that evening at the home of Samuel F. B. Morse.

The Sketch Club had been organized soon after the formation of the National Academy. Similar to Cooper's Bread and Cheese Club, the Sketch Club also provided occasions where men interested in the arts could meet. Much of the vitality had vanished from Cooper's Club after he departed for Europe. Many members of the new club had been uncomfortable with Cooper's extravagance. They agreed to conduct meetings not at hotels but at each other's homes. They

served only simple refreshments of dried fruit, crackers, honey, and milk.

Cole was happy to see his friends again. He was eager to learn how the National Academy had fared in his absence. It had moved its quarters from one all-purpose room in a house to three large rooms in Clinton Hall on Nassau Street. The gallery, the library, and the school were now housed in separate rooms. Morse, just back from Europe himself, had resumed the presidency and Dunlap had been elected to the vice-presidency. Durand had been instructing in the drawing class and Bryant had been giving lectures on mythology. The academy had recently received a gift of some valuable casts of ancient statuary which was placed on display on pedestals in the front of the school room. At the last meeting the board of directors had resolved, amid a good deal of laughter and some opposition, to have plaster fig leaves applied to the statues for the sake of modesty.

Nearly every young artist had allied himself with the new academy. The old academy was tottering along. Dr. David Hosack had been to see the leaders of the new academy about the possibility of a merger between the two. The National Academy refused. Having overcome its own financial difficulties, it did not want to be burdened by a dying institution.

The following year Cole exhibited a number of Italian views at the National Academy Exhibition. In 1834 he sent in a fanciful little painting entitled "Titian's Goblet." It showed a huge goblet containing a sea with villages on the brim and boats sailing on the water. Cole appears to have forgotten the American landscape. Moreover, he was obsessed with the idea of a series of paintings inspired by Turner's "Building" and "Decline of Carthage," showing the changes that occur in an empire over a period of time. The theme would involve five large canvases. It would be costly and require a spacious room for exhibition. Finding a sympathetic patron in the United States would be difficult.

One day Cole noticed a small, dark man making a quick tour of the gallery that adjoined the room where he painted. He did not appear to be a casual visitor. He would stand for a moment close to a painting with his chin uplifted and his black brows drawn, then he would dart on to the next with a brisk side-step. He gave each paint-

ing his undivided attention. Cole's curiosity was aroused, and later, he learned that the determined gentleman's name was Luman Reed.

Luman Reed had grown up on the banks of the Hudson River in a small town of Coxsackie, New York, some twenty-five miles south of Albany. As a young man he had worked on a sloop that carried produce from nearby farms to be sold in New York City. With money from the sale of wheat, vegetables, and other farm produce, he bought manufactured goods in the city, which he carried back up the river to sell at his country store. Reed had a gift for hard bargaining and had soon saved enough money to set up his own wholesale grocery business in New York City. As one of a growing number of New Yorkers benefiting from the cheap and safe transportation of produce by way of the Erie Canal, Reed, by 1832, had made a fortune. He had built a mansion on Greenwich Street and had begun to buy European paintings by Old Masters to hang on its walls. When he discovered that his art collection consisted not of authentic works of art, but of copies, like most of the so-called Old Masters in the United States at that time, he sold them quickly. He then turned his interest to the work being done by living Americans.

Spending an afternoon in an artist's studio was a relaxing diversion from business concerns. Reed listened sympathetically to the artists' problems and enjoyed telling them of his own dreams. He spoke of his intentions to convert the third floor of his new house into a painting gallery that would be open to visitors once a week. In a city without any museums where American painting could be permanently exhibited (the National Academy exhibitions were open only for three months and nothing could be exhibited a second time) Reed's idea was an extremely important gesture in furthering interest in American painting.

When Cole heard of Reed's intentions, he recognized the opportunity for which he had been hoping. If he could convince Reed to commission the five-painting series, it could be seen by the public and have the widespread influence for which he so hoped. In September 1833, Cole wrote to Reed, "I mentioned to you a favorite subject that I had been cherishing for several years with the *faint* hope that some day or other, I might be able to embody it." Cole told Reed that he wanted to paint a series of pictures that showed the changes

of a landscape as man progressed from the primitive state to civilization, from the destruction of that civilization to the return of the land to its natural state. Reed, who never dictated the subjects that artists should paint, accepted the idea and commissioned Cole to paint the series for twenty-five hundred dollars.

The little merchant with dark, quizzical brows and penetrating eyes had become so much a part of the artists' lives that they elected him a member of the Sketch Club. At these meetings he became particularly friendly with Asher B. Durand. Durand had been devoting most of his efforts to the engraving of bank notes. In those days each bank issued its own specially designed paper money. The banks had to employ the very top craftsmen to engrave the bank notes so they could not be easily counterfeited. Since Durand held the highest reputation in that field, he was swamped with orders and his business had become highly profitable.

Durand made such a good living that he was able to build his own house on Amity Street near Washington Square in the outskirts of the city. He lived there happily with his wife, his son, and three daughters until tragedy struck the household. One daughter died at age two, and after a long illness, his wife, Lucy, died. Left alone with three small children, Durand had to take stock of his life. He was making a good living and had acquired prestige, but engraving was very tedious. He had serious doubts about continuing. Over the years he had taken just enough time off to paint a landscape, a portrait, or a biblical scene for the National Academy exhibitions. He had been offered a few portrait commissions, but not enough to give up engraving entirely. One day he confided to Reed his desire to move full-time to painting. Reed agreed to launch Durand on his new career. He offered him a commission to paint portraits of all the Presidents of the United States for his new gallery.

There had been seven Presidents up to that time. George Washington, John Adams, Thomas Jefferson, James Madison, and James Monroe were dead. Their portraits were to be copied from ones painted during their lifetime by Gilbert Stuart. Reed arranged the sitting with John Quincy Adams, who was residing just outside Boston in Quincy, Massachusetts. In June 1835, Reed accompanied Durand to Boston. The kindly merchant, the awe-struck artist, and the staid former President dined together at Adams' home in Quincy.

Durand enjoyed the fine wines and champagne. Adams enjoyed sitting for his portrait, and Durand portrayed him in one of the finest characterizations of his career.

Reed introduced Durand to many of his prominent friends, and the young artist was soon scheduled with portrait sittings for months. He wrote home that Mr. Reed "seems to think of nothing else while here but to promote my interests." Reed had often said that he thought it a privilege to be able to give encouragement and support to better men than himself. He liked to encourage Durand by telling him that if he were as good a painter as he thought he was, he would some day ride in a carriage. The homespun artist did not share such a lofty dream; he hoped for nothing more than to be able to continue to walk to work.

In Washington Durand had to fend for himself. Andrew Jackson was then serving his second term in the White House. Much of Durand's time was spent waiting to request a sitting with the President and then waiting longer for an answer. Finally, he was able to set up his easel in the President's office. What a contrast President Jackson made to the corpulent, sedate Adams! Jackson sat tall, erect, with a sharp-boned face marked by nervous energy. He moved incessantly, fiddling through stacks of paper on his right, studying documents on his left, scribbling notes in the middle, and signing papers on his knees; all the time puffing away on his pipe. Occasionally he bolted up and disappeared into the adjoining cabinet room. Through the closed doors Durand heard the most heated disputes peppered with exclamations of "by the Eternal," and what Durand politely described as "less temperate expletives."

No sooner had Durand completed the presidential portraits than Reed put him to work painting scenes on the doors and walls of his art gallery. Meanwhile, Cole, in Catskill Village, had completed the first and second paintings of "The Course of Empire" series. "The Savage State" showed primitive man hunting deer in the forests, and "The Pastoral State" showed the next stage—the farmer plowing in the fields and building villages. Each scene was located in an imagnary landscape on the shore of a broad harbor.

The third painting, "The Consummation of the Empire," was the most difficult. The wooded shoreline had grown into a classical city crowded with temples, colonnades, and aqueducts all teeming with

people enjoying their luxurious condition. Cole became bogged down in the wealth of detail he intended to display here. He found that the numerous human figures took an inordinate amount of time, and the ornate buildings were difficult to organize. He grew tired of the "gaud and glitter"—and the decadent city life he was depicting was repellent to this plain, quiet artist.

Months later Cole was still working on the painting. He was becoming thoroughly discouraged and could no longer recognize where his mistakes were in order to correct them. He now considered the fact that he had attempted a composition far too complicated and should perhaps begin again, this time making the horizon lower and the objects fewer. It began to look as if Cole, forever dissatisfied with his work, might despair altogether and abandon the project. Moreover, his finances were getting low. During the two years he had worked on "The Course of Empire" he was not bringing in any income from other sources. When he wrote to Luman Reed for help, his generous patron agreed to raise his price to five thousand dollars. Reed advised him to take a break from the series and paint a picture for exhibition and sale.

Cole put aside his large series, and searched through his sketches for a scene that would be familiar to many people. He found a view of the fertile Connecticut River Valley taken from the wooded summit of Mount Holyoke near Northampton, Massachusetts. He worked it up into a finished oil painting entitled "The Oxbow" (see color insert). Taking the theme of the first two paintings in "The Course of Empire" series, the savage and the pastoral state, he contrasted the wilderness on the mountainside with the farms in the valley. Showing his preference for the wild regions of nature, he placed himself at his easel between two boulders on the heavily wooded slope. Rather than gazing at the farmers harvesting their hay far below, he turns his head to look out of the painting as if inviting the spectator to join him in his favorite spot. With a confidence not displayed before his trip to Europe, Cole painted the foliage with quick, lively strokes that give a freshness to this painting that cannot be found in his earlier work.

Finished in time for the National Academy Spring Exhibition of 1836, "The Oxbow" .was greeted with lavish praise. One visitor to the exhibition, Charles Talbot, admired the painting so much he was

willing to pay five hundred dollars for it. Today, it hangs in the Metropolitan Museum as one of Cole's best-loved paintings.

Cole immediately went back to work on "The Consummation," his attitude toward his work now greatly improved. He even joked that because it was a rainy day, it might "be a good time to paint the water in the fountain." When the painting was finally completed, Cole exclaimed, "I feel like a man who has had a long fatiguing journey and is just taking off his knapsack."

Durand, in New York City, was painting the door panels of Reed's gallery when suddenly Reed became ill. Deeply concerned, he kept Cole, in Catskill Village, posted as to Reed's health. "His disease is said to be remittent fever with inflammation of the liver," he wrote. "I doubt not that you will look with the same anxiety as myself to the happy moment of his recovery." Unfortunately, Reed did not recover. Grief-stricken, Cole and Durand met at the funeral. So much of their income had depended on their generous backer. Durand worried about the future of his portrait commissions; Cole was concerned about his half-finished "Course of Empire." He did not know whether to continue with the series. Would he ever be paid for the work he had already completed? It was an uneasy time. At last Cole learned that Reed's widow would acknowledge her late husband's commitments and he completed the last two paintings in the series, "Destruction" and "Desolation."

"The Course of Empire" was exhibited as a single attraction at the National Academy in the fall of 1836. William Cullen Bryant described it as the "most remarkable and characteristic" of Cole's work. James Fenimore Cooper considered it "the work of the highest genius this country has ever produced." He regarded it "a new thing to see landscape painting raised to a level with the heroic in historical composition." Cooper predicted that the "day will come when the series will command fifty thousand dollars." As he was praising Cole's effort to unite the moral and intellectual in landscape painting, he admitted that "some of Cole's little American landscapes are perfect gems in their way." Other critics felt that scenes from the imagination did not have the "truth-telling" force that his realistic ones had. They were disappointed that Cole spent so much time on imaginary scenes when vast regions of newly discovered natural beauty were still untouched by the artist's brush. "The Course of Empire," like "The Expulsion,"

appeared to be influenced by European tradition. Few dared to say so, but many felt that Cole had forsaken his adopted country by painting this allegorical series. The exhibition itself attracted very few visitors. Admission fees did not even pay for the cost of renting the gallery.

The final triumph of nature over civilization was an apt theme for a man often depressed by the destruction of his beloved forests. During the spring and summer of 1836, as Cole worked on "The Course of Empire," he made a number of observations in his letters about the encroachment of civilization on the wilderness he loved. "I took a walk last evening, up the valley of the Catskill, where they are now constructing a railroad," he wrote. "This was once my favorite walk; but now the charm of solitude and quietness is gone." Then he complained to a friend, "They are cutting down all the trees in the beautiful valley on which I have looked so often with a loving eye." And added, "Tell this to Durand—not that I wish to give him pain, but that I want him to join with me in maledictions on the dollar-god-ded utilitarians."

Cole was surely in advance of his times in his concern for the preservation of natural settings. To Cole there were strong moral implications in the invasion of civilization into the wilderness. He believed that man could not survive separated from nature. God's creation, nature, was good, but man's creation, the city, was bad and held the seeds of its own destruction. Cole saw the American dream —this Garden of Eden—as frail and liable to destruction—whether through foreign invaders or our own "dollar-godded utilitarians"—as any other civilization.

Luman Reed's death destroyed Cole's hopes that the series could be permanently viewed in Reed's gallery. Instead, the five paintings were stacked away in storage rooms. As a result of the untiring efforts of Reed's business partner and son-in-law, Jonathan Sturges, Reed's collection was donated in 1858, ten years after Cole's death, to the New York Historical Society, where it is permanently exhibited today.

VII

Durand Turns to Landscape

From the decks of steamboats and sloops sailing up the Hudson River, passengers could catch a distant glimpse of the white-columned porch of the famous Catskill Mountain House. Docking at Catskill Landing, the boats discharged passengers by the hordes heading for this famed hotel, daringly perched on the edge of a mountain cliff. In summers the village of Catskill was bustling with visitors; some were seeking the laughter and music of the mountain resort, others absorbing the refreshment of the nearby natural wonders, still others curious to see the village that claimed the honor of being the home of Rip Van Winkle. In winter doors and windows of hotels and wayside taverns were boarded up. Snowdrifts blocked the roads, and ice froze over the river. The village quieted. Only the regular folk stopped in at the local stores. But occasionally a summer visitor lingered there through the long winter. Town residents recognized one of them as the artist Thomas Cole.

During the years that Cole had been working on "The Course of Empire," he had been spending longer periods of time in Catskill Vil-

lage. Now he decided to make it his permanent residence. He was glad to retire from the mainstream of city life. He admitted that New York City filled him with "a presentiment of evil." It also deadened his response to nature. He was happiest when he could escape to the woods.

Cole was, a man of medium height with a thoughtful, clean-shaven face. His eyes had a dreamy look about them, and filled quickly with tears when he was moved by compassion. His skin was extraordinarily white. His friends described him as having an air of "mild femininity" about him, and noted that he walked with a "peculiar rising and falling gait." Although capable of enjoying innocent fun, he was often moody and introspective. He did not smoke, or drink anything but an occasional glass of wine. He was painfully conscious of his lack of poise, and parties inhibited him so much that on leaving them he felt as though he had been liberated from jail.

Cole kept many of his private thoughts in a journal. Sometimes in poetry, sometimes in prose, he described the scenery he encountered on his long and solitary walks into the wilderness. His words reveal a close relationship with nature. He jotted down on an overcast November afternoon: "Gloomy days have come at last, and brought with them to my mind a shade of their own sadness." The weather and seasons so dictated his moods that when the first signs of spring appeared, his happiness also returned. He wrote elatedly: "The Spring has come at last . . . The mountains have taken their pearly hue, and the streams leap and glitter as though some crystal mountain was thawing beneath the sun."

Cole longed to find others with whom he could share his response to nature. He sometimes felt isolated, and, at times, his journal reveals that he drifted into a deep loneliness. "My thoughts and feelings run," he wrote, ". . . in a different channel: if revealed, they would be little understood or appreciated." He asked himself, "But am I better or wiser for this sense and perception of the beautiful, which I imagine myself to possess in a greater degree than the many?" Cole was not certain. Coarse people made him irritable, and he grew impatient with those who did not share his love of nature.

Cole was then thirty-five years old and tired of bachelorhood. He was determined not to let this lonely state persist forever. But he found that in matters of love he tended to be too idealistic. He wrote

in his journal: "I find that when I fall in love it is with an ideal character, which I have attributed to some earthly fair; and as the ideal does not wear very well in this world, I too soon behold that the object of my adoration is no goddess." In a more practical manner, he reasoned that if his chosen lady was good-looking, amiable, and sensible, he would ask no more except that she make his "feelings her own and love one heart and soul."

Cole had taken rooms in a large brick house owned by a kindly gentleman, Mr. Thompson. A honey locust tree shaded the front lawn, wisteria trimmed the porch, and neat little brick paths ran through the vineyards, rose gardens, and orchards to his storehouse-studio, which stood on a ridge overlooking the Hudson. On summer evenings Cole enjoyed the company of the Thompson household as they sat on the long front porch that looked out at the blue mountains of the Catskills.

Maria Bartow, Thompson's niece, came regularly to sit with them. She had a sweet face framed by brown wavy hair, parted in the center and tied behind with a ribbon. When she lowered her large brown eyes, she reminded Cole of a madonna. She began to join Cole in his favorite pastime of gathering summer mosses. She sensed in nature the mirror of her own moods as much as he, and for a time Cole's loneliness vanished.

It was not long before Asher B. Durand, in New York City, having already been informed of the news, received a note from a nervous groom. "Don't let me stand up to the parson without a single soul to keep me in countenance," Cole pleaded. "Come—Come—Come! I will not be disappointed."

Durand was not able to make the trip to Catskill Village to attend the wedding that November. His duties as instructor and recording secretary at the National Academy were pressing and his portrait commissions, despite Reed's death, were flourishing. Under President Jackson's policies of easy credit, there was a great deal of new wealth in New York, and portraiture, being a luxury profession, was prospering.

The extravagance that Cole had depicted in "The Consummation of the Empire" was symbolic of New York in 1836. Reckless expansion and luxurious living had turned the city into a harbor of bad taste and flaunted wealth. "The Course of Empire" had proved more

immediately prophetic than its critics guessed. In May 1837, panic engulfed the nation. Banks closed, business went bankrupt, and thousands of workers lost their jobs.

What had appeared to Durand to be a promising career, suddenly collapsed. When the financial crisis struck, people's desire for portraits vanished. Business was paralyzed. Stores along Broadway were closed and boarded up, building construction came to a halt, and the shipyards became idle. Almshouses were overflowing and hundreds of unemployed begged on the streets. Angry crowds grew into violent mobs. Stores and warehouses were sacked. New York was transformed overnight from a city of gaiety and wealth to a city of misery and terror. Durand wrote to Cole in Catskill of his despair.

The depressed condition of the country was not so apparent in the little mountain village. Cole tried to console Durand. "I am sorry that you are at times so depressed in spirits; you must come and live in the country. Nature is a sovereign remedy. You sit, I know you do, day after day, in a close, air-tight room, toiling, stagnating and breeding dissatisfaction at all you do." Cole presented a solution: "If you had the untainted breeze to breathe, your body would be invigorated, your spirits buoyant and your pictures would charm even you."

As summer approached, and the depression grew worse, Durand considered taking Cole's advice. With no portrait commissions coming in, he decided to turn his attention to landscape. Cole would be glad to give advice and instruction. In the summer of 1837 Durand and his second wife (he had remarried in 1834) arranged to join Cole and his bride on a sketching trip to Schroon Lake in the eastern Adirondacks. They stayed in a farmhouse run by the hospitable Beebe family. They enjoyed home-cooked meals served on an old knotted pine table after long days of rowing on the lake, rambling about its shores, and trudging through the forest, the two artists sketching everywhere they went.

Durand was relieved to be away from the turmoil of the city, enjoying scenery that was entirely new to him. He and Cole tramped through the forests in search of the perfect view of the most majestic mountain in the region—Schroon Mountain (now called Hoffman Mountain). They dashed down one slope and up another as each peak before them promised a fuller view of the mountain. Together

they skirted the swampy shore of a pond, scrambled through the black logs of a recent burned-out area, and arrived at a new clearing. They passed a log cabin whose inhabitants, Cole reported, were aghast at two strangers "sweeping across their domains without stopping to ask questions or say 'good day.'" When they obtained the topmost knoll, they looked west, but a clump of woods on the hill hid the anticipated peak. For the first time Cole wished that the ax had not been stopped. They entered the wood and found it to be only a narrow strip. When they emerged on the other side, the mountain rose before them in silent grandeur. Below, the forest stretched to the mountain base. The artists sketched silently for hours. The woods were so still that the sound of running water far below sounded like the "whisperings of midnight."

Cole allowed an entire year to pass before he attempted to work his sketches up into a painting. He never tried to paint scenes immediately on returning from them. He waited until the details had grown fuzzy, leaving the essential parts dominant in his mind.

The completed painting, "Schroon Mountain," appears at first glance to be a simple landscape without hidden meaning, but on further observation the natural features take on a deeper significance. In the foreground, the twisted shape of the splintered tree gestures like a tormented spirit. In the background, the mountain rises above the knotted and gnarled underbrush. Where its peak touches the sky, the black storm clouds disperse. Does Cole suggest that human grief vanished in the higher regions? By combining his love of nature with a spiritual statement, Cole had produced a painting that was to inspire future generations of artists.

"Schroon Mountain" was highly praised when it appeared in the National Academy Exhibition of 1838. In the same exhibition Durand had felt satisfied enough with his work to exhibit nine landscape paintings. The public and press were delighted that Durand, so long acclaimed a first-rate engraver and reputable portrait painter, would at last turn his talent to the depiction of American scenery. Finding that his landscapes sold quickly enough to support him, Durand abandoned portraiture, announcing humorously to his friends, "I leave the human trunk and turn to the trunk of trees."

Durand wondered, now that he had achieved some success in landscape painting, whether Cole might be experiencing some regret

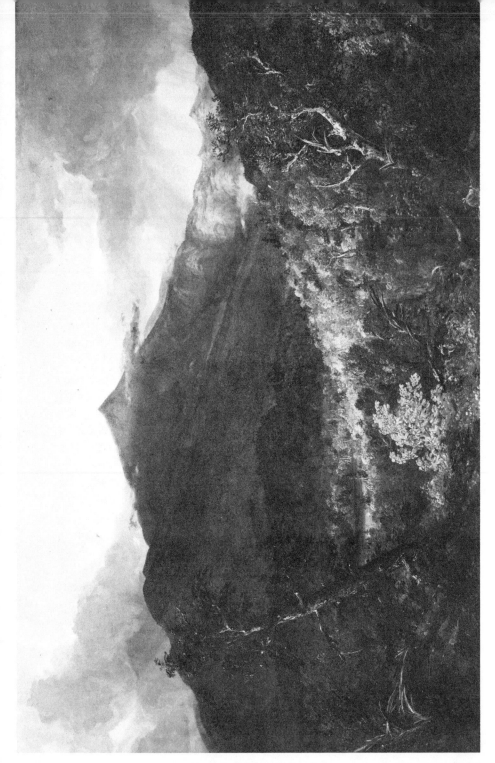

SCHROON MOUNTAIN, ADIRONDACKS by Thomas Cole. The Cleveland Museum of Art, The Hinman B. Hurlbut Collection.

for assisting a competitor. Durand wrote to his friend, "I am still willing to confess myself a trespasser on your ground, tho' I trust, not a poacher." Cole considered him neither; he was happy to have his city friend as a companion on sketching trips, and hoped that he would return to Catskill in order "to gather up the flesh" he had "dropped from his bones when last there."

During the early part of his landscape career, Durand painted American, European, and classical views. He also painted a two-part allegory inspired by Cole's "Voyage of Life." On returning home from his trip to the Adirondacks with Cole, Durand immediately proceeded to work his sketches up into an oil painting of "Schroon Mountain," but his letters reveal that he had great difficulty with it, and he was unable to complete it. Durand's preferred subject was not the thickly wooded slopes of mountain regions, but the rolling pastures and grazing cows that reminded him of the farmland he knew as a boy.

Prior to the nineteenth century, artists had learned how to paint from art of the past. Now they began to insist that they must learn directly from nature, but Durand's first landscapes reveal that he, too, modeled his work after traditional art. He was strongly influenced by Claude Lorrain, whose works he had studied from engravings, and later, during his trip to Europe, from the originals. In his paintings Durand cast a soft, dreamlike mood over the scenery, as though he was looking into the past rather than confronting nature at firsthand. His landscapes often take on more of the poetic appearance of the Italian scenery that Claude Lorrain painted in the seventeenth century than the rugged American countryside. Cole, therefore, remained unrivaled as the only landscape painter whose imagination had the power to convey the unique wonder of the American wilderness.

VIII

The Voyage of Life

From his Catskill Village studio, Cole continued to send a rich assortment of paintings to the annual National Academy exhibitions. He made occasional jaunts to New York City, popping in at the Sketch Club meetings, and faithfully attending the spring openings of the National Academy. He continued to rely on the stimulation of nature, happy that he could now flee into the nearby hollows and cloves at any time he wished.

Although his parents had died, his sisters Harriet and Sarah lived with him and his wife, and were dependent on him for support. He now had two young children, Mary and Theddy. He had no income from sources outside his painting. His business judgment was poor. Maintaining such a large household under these circumstances often put Cole under heavy financial pressure. In order to fill whatever commissions were offered, he painted a much broader range of subjects than the wilderness scenes for which he is best known. In 1838 he was commissioned by Boston clients to paint a number of views of the Arno River in Florence—so many, in fact, that he joked

to Durand that he was afraid the Arno might flood Boston. For Peter Stuyvesant of New York, that same year he painted a literary scene inspired by the popular novels of Sir Walter Scott. He also painted a classical scene which was reviewed so favorably by the press that a businessman from Georgia bought it without having seen it. When Cole had no specific commission to fill, he turned out mountain landscapes that would sell easily and quickly in the city. Although Cole was heavily dependent on these commissions and landscapes for income, he began to feel that specific views were less worthy of his efforts as a painter than his moral themes.

Cole believed, as did many people of his time, that landscape painting, no matter how brilliant, could not bring him the prestige he so desired. The eighteenth-century theories of the English artist, Sir Joshua Reynolds, were still influential in Cole's day. Reynolds taught that the status of an artist was determined by the kind of subject he chose to paint. Historical painting, which included biblical and allegorical subjects, held the highest rank because it depicted heroic deeds and universal truths that contributed to the moral improvement of mankind. Pure landscape painting was considered a lower class of art. The understanding that landscape painting held moral significance did not become widely accepted until the 1850s. Until that time artists were caught in a dilemma. Cole divided his efforts between painting pure landscapes for an admiring public and allegorical series for the attainment of lasting fame. As he grew older, he mistakenly saw his only way to immortality through paintings that described religious truths.

So Cole now began to contemplate another series of paintings that were to teach a moral lesson. Now it is not the empire that rides the stormy path between birth and death but man himself.

Completed in 1839, this four-picture series—entitled "Voyage of Life"—showed man in four stages of life: childhood, youth, manhood; and old age. The first painting shows a child gliding out of a dark cave in a boat with an angel at the helm, and a full hourglass at the bow. The stream is narrow, indicating the narrow experience of childhood. The season is spring and the mood is one of joyousness and wonder.

In "Youth," the second picture, the season is summer and the placid stream widens as the experience of life grows. The guardian

LAST OF THE BUFFALO by Albert Bierstadt. Gift of Mrs. Albert Bierstadt. In the Collection of the Corcoran Gallery of Art, Washington, D.C.

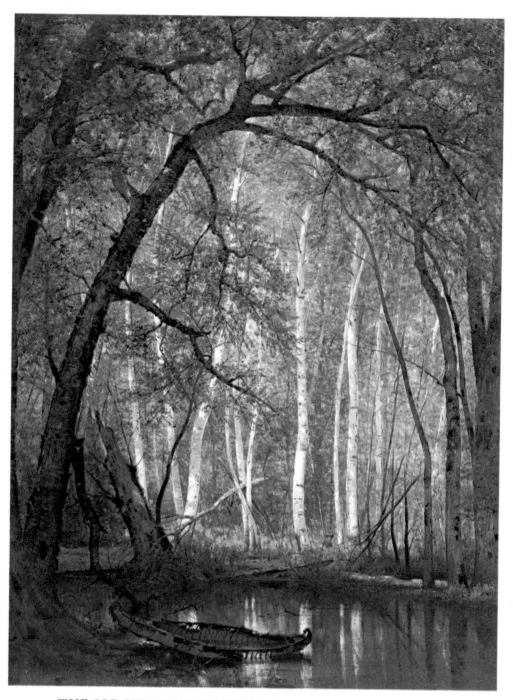

THE OLD HUNTING GROUNDS by Worthington Whittredge. Reynolda House, Inc.

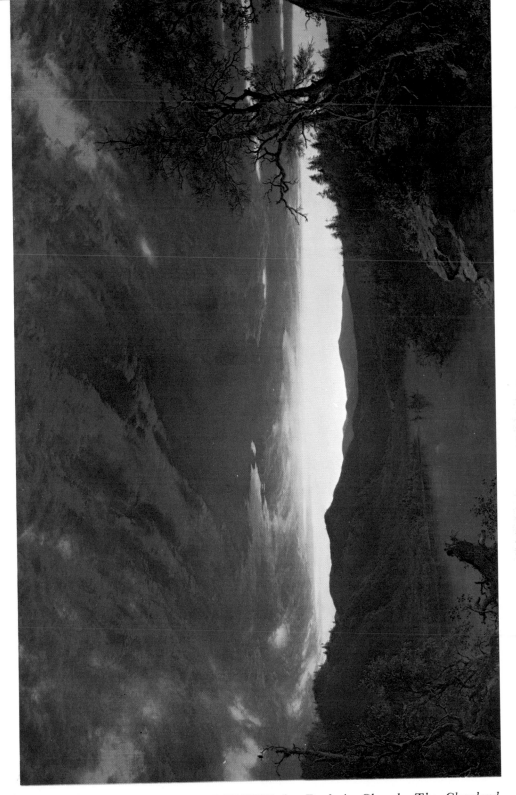

TWILIGHT IN THE WILDERNESS by Frederic Church. The Cleveland Museum of Art, Purchase, Mr. and Mrs. William H. Marlatt Fund.

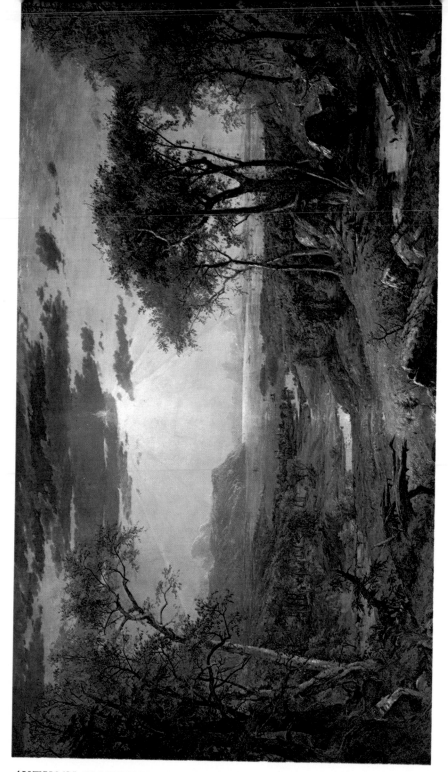

*AUTUMN ON THE HUDSON RIVER by Jasper F. Cropsey. National
Gallery of Art, Washington, D.C. Gift of the Avalon Foundation.*

angel waves good-by to the youth, now at the helm of the boat, for he is ready to steer his own life. The youth looks with confidence at domed temples in the clear sky, but a glimpse of more turbulent waters downstream suggests that his daydreams will soon vanish.

In the third painting, autumn storms have torn the helm from the boat and the raging current is propelling the voyager—now fronting the perils of manhood—toward an abrupt drop. His youthful dreams have been shattered. The guardian spirit sits above in the clouds watching with concern. It appears that if the voyager turns to a higher power, he can be saved from inevitable destruction.

Old age has humbled the voyager in the final work of the series. The hourglass has broken off the bow. The river has run into the sea. The voyager sits humbly in his tempest-battered craft, but he now looks to the sky. Faith has returned to the old man. The guardian angel makes his presence known once again; he signals to the old traveler that it is time to return to the Heavenly Kingdom from which his voyage had begun.

This series had been commissioned by the New York merchant Samuel Ward, but once again Cole's patron died before he had completed the project. "The Voyage of Life" became tied up in legal problems pending the settlement of Ward's estate. At first, Cole thought that he could resolve the difficulties he had with the executors who were demanding one half of the proceeds from the admission fee if "The Voyage of Life" were to be exhibited, but he finally despaired of this ever occurring. So urgent was it for Cole to spread his message that he decided to paint the series again. Wishing at the same time to revive his spirits and his health, he decided to take another trip to Europe.

By November of 1841, Cole had found a studio in Rome where he settled for the winter in order to paint duplicates of "The Voyage of Life" series. He felt lonely without Maria and their two children. He wrote to his wife, "But here I am sitting in my studio, warm enough, but confoundedly flea-bitten, a large canvas on my easel with some chalkmarks upon it . . . But how can I paint without you to praise, or to criticize, and little Theddy to come for papa to go to dinner, and little Mary with her black eyes to come and kiss the figures in my pictures." Composing his new paintings from water colors of the originals, Cole set to work. Two months later he re-

ported: "I am getting on bravely with my pictures. The first and the third are completed, and I am building the castle on the second."

After he finished the last painting, he took a trip to Sicily. With a woolen cap on his head, coarse woolen stockings pulled over his pants, and a pistol in his pocket, he climbed on muleback to the peak of Mount Aetna. He gazed with wonder into the gloomy crater, noting how the smoke hung like wreaths about the crags, and then sprang over the edge and vanished in the clear air. He made a number of sketches of the famous volcano. He then returned to Rome, went on to Milan, through Switzerland, down the Rhine to Rotterdam, across the channel, and from England booked passage home on one of the first steamships to have crossed the Atlantic, *The Great Western.*

After an eighteen-day voyage, the steamship docked in New York Harbor. Cole immediately hopped a steamboat up the Hudson, surprising his family by arriving home two days earlier than they had expected: "For a few weeks after my return I felt happier, perhaps, than I ever did in my life," wrote Cole. But such moments for him were short-lived.

During the winter of 1843–44 Cole arranged to hold an exhibition of his paintings in the National Academy, still located in rented rooms in Clinton Hall. The second version of "The Voyage of Life" was to be the main feature. If Mrs. Reed was willing to lend "The Course of Empire," the two great series would be on view at one time, but Mrs. Reed refused. Disappointed, but not defeated, Cole was determined to make up for the loss by painting a large picture of the Sicilian volcano, Mount Aetna, with the ruins of the Greek amphitheater in Taormina in the foreground. Having no painting rooms in New York City, Cole set up his easel in the center of the National Academy gallery surrounded by his paintings hanging on the walls. When his sister Sarah came to visit, she found him in his shirt sleeves holding a large brush in one hand and a palette piled with colors in the other. "Ah, Sarah," he said when she entered, "this is the room to paint in—and this is the way I love to paint." In the rush of last-minute enthusiasm, Cole completed the painting in record-breaking time. When it was bought by Daniel Wadsworth for his Hartford museum for five hundred dollars, Cole commented, "Pretty good for five days work."

Once again the exhibition itself proved unprofitable. The admis-

sion fee seemed too high for people not yet fully recovered from the Panic of 1837, and few came to see it. The National Academy exempted Cole from paying the rent and concluded that one-man exhibitions were not profitable. Eventually, this version of "The Voyage of Life" was sold to George K. Shoenberger of Cincinnati, and it remained for many years hidden away in a home for the aged (to which his mansion had been converted) until its rediscovery in 1962, and its subsequent purchase by the National Gallery in Washington, D.C.

An incident occurred at a Sketch Club meeting soon after "The Voyage of Life" was exhibited that revealed the gravity with which Cole approached his mission as an artist. It was the custom for the host to choose a theme for the artists to illustrate. The given subject that evening was "Just in Time." One artist depicted a boy jumping a fence just in time to escape an enraged bull. Another depicted a half-starved man entering a house just in time for a lavish dinner. The humorous genre painter William Sidney Mount looked particularly mischievous that evening. When his turn came to place his drawing on the table, he showed a sketch of an angel lifting an old voyager to heaven by the collar of his suit just in time to escape the grasp of the Devil, who was attempting to seize the old man from below. It was immediately recognized as a caricature of Cole's "The Voyage of Life," and the members enjoyed a good laugh—with the exception of Cole, who appeared mortified. One observer reported, "It made us all feel sad to see Cole take the joke so seriously."

Cole persisted to search for patrons who would commission paintings with a moral. Jonathan Sturges, in an attempt to fill the gap left by Reed's death, had become an enthusiastic collector of Cole's landscapes. Cole wrote to him about an idea for a series that would arouse a "holy feeling" in the minds of people. Sturges was not interested. He did not have a room in which to hang a series of large paintings.

Cole then wrote to one of his first patrons, Daniel Wadsworth, whose new museum could provide the spacious setting these paintings required. Instead of commissioning this work, Wadsworth replied with a request. Would he be willing to take on a young man from Hartford as a pupil? He has "received a good education and has considerable mechanical genius," Wadsworth wrote. "His personal

appearance and manner are prepossessing." Cole had never before taken a pupil, but young Frederic Church's father was willing to pay in any terms that Cole asked. The fee would help him out of his financial difficulties. Cole agreed to accept the offer.

On June 4, 1844, the ferry docked at Catskill Landing. A slender young man of eighteen climbed the long hill to Thomas Cole's house. At the gate, Tiger, a dog with ugly eyes, ran out to bark at the newcomer. Theddy and Mary scampered down the steep porch steps to catch their first glimpse of the young artist who had come to study with their father. When Church caught his first sight of the frail artist and his warmhearted wife, he felt assured that he had decided upon the right course.

Frederic Church had been born in Hartford, Connecticut, on May 4, 1826. He was descended from a long line of Puritans. His father could trace his ancestry back to Richard Church, one of the founders of Hartford in the seventeenth century. His mother traced hers back to William Bradford, the second governor of Plymouth Colony. Frederic's father, as enterprising as his forebears, had a hand in a variety of prosperous businesses—from a paper mill to a jewelry store. He owned valuable land in the center of Hartford and his proven skill in handling money had earned him positions as director of a bank and adjuster for the Aetna Insurance Company. He supplied material comforts and prestige for his son and two daughters, as his wife provided strong moral and religious guidance. A more stable and secure heritage could hardly have been found in mid-nineteenth-century America.

As a boy, young Frederic had accompanied his father on visits to Daniel Wadsworth's home. He passed the long hours as the gentlemen talked business, gazing on the paintings that hung on the walls— among them "Kaaterskill Falls," painted by Cole the year Church was born. He had also been given a peek at Cole's recently painted "Mt. Aetna from Taormina," which was in Wadsworth's safekeeping before the opening of his proposed museum. These paintings had acquainted Frederic with Cole's work from an early age, and by the time he was eighteen he had set his hopes upon becoming an artist.

His father disapproved of Frederic's decision. He felt that an artistic career was beneath a young man of his advantages. He had his heart set on his son's becoming a physician. The skillfulness of

Frederic's sketches and the seriousness with which he pursued his studies with local artists finally convinced the staunch Connecticut Yankee to yield to his son's wishes. Now committed to helping his son, Mr. Church enlisted the services of his friend, Mr. Wadsworth, to persuade the most renowned landscape painter in the country to take his son on as a pupil.

Thomas Cole was delighted with his young student. "Church has the finest eye for drawing in the world," he often commented. They spent the fine summer days rambling through the Catskills, making studies from nature. Church adopted Cole's method of jotting down written descriptions of color and atmosphere on his pencil sketches. When he began to work in oil, he was quick to pick up the techniques that Cole had so laboriously taught himself. After one year Cole thought his pupil ready to exhibit a painting called "Twilight Among the Mountains" at the National Academy. After two years, Church was ready to strike out on his own. Bidding farewell to his teacher, the young artist returned to Hartford to set up his own studio.

IX

The Art Union

Depression and self-pity began to take hold of Cole after the departure of Church. He began to realize how isolated he had become from the mainstream of artistic life in the city. In winters he did not dare risk the rough and lengthy stagecoach ride over one hundred miles of icy roads to New York. The thought of Sketch Club meetings brought on the painful memory of Mount's mockery of his "Voyage of Life." He rarely attended any more. With snowdrifts blown against the window panes and the stove warming a snug corner of the room, Cole scratched some forlorn words on his stationery to a friend in New York, "I have heard of late next to nothing," he wrote. "I am in a remote place. I am forgotten by the great world, if I ever was known."

Cole was also saddened by the financial failure of his exhibitions and his inability to find patrons for another series of paintings that would teach a lesson. He wondered whether his unhappy situation was caused by his deficiency as a painter or the fault of the times in which he lived. When years earlier he had admitted that he would

give his left hand to say he was born in America, it now appeared that his adopted country was letting him down. That the public would not sympathize with his aim of uplifting mankind through art, and reward him accordingly, made him unhappy about America as a place of culture. "I am not the painter I should have been had there been a higher taste," he complained. For years his patrons and friends had been urging him to direct his talent toward painting the scenic beauty of America. Cole replied angrily to these pleas, stating that he refused to remain a "mere leaf painter," and stubbornly threw more energy than ever into painting moral allegories for which he had no patrons.

The taste of America was turning increasingly to landscape painting. Not Cole's moral allegories, as he hoped, but his American views, which he now painted only for quick sale, were to inspire younger artists. Cole grew embittered toward this new generation for not taking up the moral aspect of art. During a visit from Durand, he spoke badly of nearly all of them. Durand decided that he might be jealous.

Cole was now well into his forties. His embitterment was beginning to make a mark on his appearance. His shoulders became stooped and his eyes took on a strange, faraway look. He became obsessed with his work. Many people whom he used to welcome at his studio were met by an artist so absorbed in his painting that they received only a quick smile and a gentle "go away."

The local Episcopal minister, Reverend Louis Legrand Noble, became Cole's close friend and later his biographer. Together they took long walks in the fields and woods. Reverend Noble spoke often of the meaning of Christianity. Cole began to attend church services regularly. As he painted, his wife read the Bible to him. He now decided to be baptized and to join the church. Finding a new religious outlet seemed to provoke Cole into a spiritual mania. The allegorical series that he described to his patrons appeared to be more like sermons than works of art. Durand was disturbed by the changes in his friend. After a visit he was convinced that Cole never again would paint a great landscape painting.

The passing of time had preserved Durand well. His hair, though now decidedly gray, was long and thick. He wore a full beard. His animated brown eyes shone brighter than ever out of his

winning face. His simplicity, cheerfulness, and humor brought him many friends. His helpfulness and sound judgment brought him influence. Younger painters swarmed to him for advice. On a trip to Europe in 1840 he enjoyed the company of three younger men, one of whom, John Kensett, would prove to be a major contributor to the development of American landscape. Born on March 2, 1816, in Cheshire, Connecticut, the pudgy, amiable Kensett was twenty years younger than Durand. He shared with the older artist a background in engraving, and worked for a time in the firm of Durand's former partner, Peter Maverick. Durand willingly offered assistance to Kensett, who, like himself years ago, was trying to change his profession from that of engraver to fine artist.

Durand had proved himself one of the most vital members of the National Academy, giving regular instruction at the school, sitting on the council and many of the special committees. When Samuel F. B. Morse resigned from the presidency in 1845 to devote his time to the telegraph, Durand was elected to the position. The following year the National Academy had its strongest year in its history. Three hundred forty-six works of art were exhibited and $5,665 was collected in admission fees. The National Academy had come a long way from its first exhibition. New Yorkers by the hundreds were attending these showings of contemporary paintings, and were willing to pay to do so. The American Academy had closed its doors long ago, leaving no institution in New York to promote Old Masters. The taste of the new spectators was being formed entirely by contemporary works of art.

When only a small number of wealthy men were interested in the work of a small number of artists, buying directly from the artist sufficed. Through the popular exhibitions of the National Academy, a much broader range of people had become interested in the arts. Many of them could not afford to purchase the paintings that they admired. To meet this new demand, an institution was created that employed a method of distribution that enabled people of moderate means to acquire paintings by contemporary artists. It was organized in 1842 by a group of businessmen, as the American Art Union.

Becoming a member of the Art Union cost only five dollars a year. In return, the member received an illustrated bulletin, a large engraving of an American painting, and a lottery ticket. With the

money from the subscriptions the Art Union purchased original oil paintings by contemporary American artists. They bought from established artists, unknown artists, American artists studying abroad, and foreign artists living in the United States. Paintings from all over the country were sent to the Art Union. They were hung as they were submitted. The managers met from time to time to decide which of these works they would buy. The rejected ones were taken down and returned to the artist. The purchased ones remained on the walls. This process continued from April to December. Gradually the gallery became filled with Art Union purchases. By the end of the year they were ready to be raffled off to the members.

No admission fee was charged at the Art Union. It was situated on Broadway, where people of all kinds strolled through the long skylighted galleries hung with paintings from floor to ceiling. Early in the morning children with their books and satchels romped through on their way to school. Then came the merchants in black frock coats and high hats. By noon, ladies wearing straw bonnets, flounced skirts, and large shawls stopped in on their way to do their shopping. In the evenings laborers in their Sunday coats brought their families to look at the artistic endeavors of their countrymen. During its most successful years, over half the population of New York visited the galleries.

Not only New Yorkers, but people from all over the country joined the Art Union. It set up offices in Cincinnati, Philadelphia, Trenton, and Boston. With such wide geographical distribution it was far more national than the National Academy, whose activities were confined to New York. The Art Union encouraged artists to break with the past, develop their own originality, select native subjects, and paint with freshness and simplicity. History painting, landscape, and genre, or painting of everyday life, became the most popular branches of art. In its best year it bought and distributed as many as 460 paintings, which were hung above mantels in homes all over the country. The Art Union had become the most important patron of the arts in the United States.

At first the National Academy welcomed the new art organization. Most of its members sent paintings to the Art Union regularly. Sometimes the Art Union commissioned paintings from them. They might buy as many as nine or ten paintings from one artist. In

1847 they offered Cole five hundred dollars to paint a landscape of his own choice. Cole chose a scene in the White Mountains of a log cabin on a quiet lake with the peak of Mount Chochora in the distance. He called it "Home in the Woods." Cole's patrons, however, were willing to pay as much as a thousand dollars for a landscape of similar size and subject. Artists began to complain that the Art Union was not paying what their paintings were really worth. The Art Union felt justified by their low prices because of the quantity that they bought. There were bitter disputes between the artists and the Art Union managers, but the real bone of contention came when attendance dropped at the National Academy exhibitions, as it was rising at the Art Union.

Rather than planning their special exhibitions at times that would not conflict with the National Academy openings, the shrewd Art Union managers capitalized on their rival's audience by advertising their new exhibitions immediately after the National Academy announced theirs. As a result, the National Academy receipts dropped drastically. Since the National Academy was dependent on its admission charge for survival, its exhibitions were no match for the free ones sponsored by the Art Union. Why should people attend one exhibition at twenty-five cents charge if they could see a larger one of the same artists free? The decline in funds proved doubly embarrassing as the National Academy, which had rented its quarters until this time, had just purchased its own building. The academicians (all artists) were infuriated by the tricky marketing techniques of the Art Union (all businessmen). They described the Art Union managers as their deadly enemies. President Durand called special meetings to try to solve their problems. They decided to close their art school, delay renovation on the new building, and persuade Sturges and other merchants to help meet payments on their new property. They desperately considered ways of attracting more people to the academy.

As Durand in New York City was fighting for the survival of the National Academy, Cole in Catskill Village was fighting for his own personal survival. His health had deteriorated to such a weakened state that he had contracted acute inflammation of the lungs. On February 9, 1848, Cole's friends received word that he had died.

Their anger at the Art Union momentarily subsided. They

gathered together the largest collection of Cole's paintings that had ever been shown at one time. The American Art Union offered their galleries for the memorial exhibition. The quality of the work astounded even Cole's patrons and friends. Not until after his death did they truly realize the extent of his genius.

Another event occurred that year that brought even greater recognition to Cole. The first version of "The Voyage of Life," which for years had been collecting dust in the storeroom of Samuel Ward's house, was released for sale. It was quickly snatched up by the American Art Union. People all over the country were alerted to that year's prize of four large paintings, to be won for only a five-dollar lottery ticket. What a bargain! The series that could not draw enough people to pay the gallery rent in Cole's lifetime, now became renowned all over the country. Whereas the subject did not appeal to critics and defenders of our national culture, it did appeal to the masses of people to whom it was now exhibited. For them it perfectly expressed the popular religious sentiment of the times. So sought after was this series that Art Union members increased from 9,666 to 16,-475 in one year.

The National Academy was in the worst straits ever. With receipts from admission fees as high as $5,665 in 1846, they now fell to $2,753. It looked as though the Art Union managers were going to wipe out the National Academy altogether. Debts piled up. Durand had to make the agonizing decision to ask members to contribute their paintings to sell to the Art Union in order to pay their creditors.

It was not long, however, before the Art Union met a similar fate. They too, anticipated that the sudden increase in membership would continue, so the managers bought large numbers of paintings accordingly. The expected subscriptions did not come in and the managers decided to postpone the drawing of the lottery ticket until more subscriptions were sold. Angry clients were left holding tickets for which there were no prizes. The enemies of the Art Union began to accumulate: rival organizations, underpaid artists, disappointed subscribers, and people who believed that its democratic methods were lowering the standards of art. Someone from this growing list of enemies pointed out to the district attorney what had previously been overlooked—that lotteries were against the law in New York

State. A lawsuit was brought against the Art Union, it was declared illegal, and it was disbanded. What remained of its collection, after debts were paid, is housed today with Luman Reed's collection at the New York Historical Society.

With the major threat to its existence gone, the National Academy once again provided the principal galleries at which American art was exhibited. But many changes had taken place in New York over the years, and from now on it had to share its promotion of art with the commercial art gallery.

X

The Second Generation

By 1850 the two- and three-story brick and frame houses of lower
Manhattan had been replaced by five- and six-story structures of
marble, stone, and cast iron. Omnibuses, or railcars on tracks pulled
by a team of horses, thundered down Broadway every few minutes.
Overhead wires carried messages from one telegraph office to an-
other. New public buildings boasted steam heat and grand hotels ad-
vertised a bathroom and toilet per floor. Sanitation service and an or-
ganized police force had just been started. The population had more
than tripled since 1825. Tenements had been built to house the hun-
dreds of Irish and German immigrants arriving in the city. Few single
residences remained on the south tip of the island. Fifth Avenue had
become the fashionable place to live. Fine brownstone houses stood
from Washington Square northward. With the city now built solidly
up to Thirty-fourth Street, and threatening to quickly cover the entire
island, such farsighted men as William Cullen Bryant had begun to
gather support to preserve unspoilt land for Central Park.

The world of arts was also changing. Artists William Dunlap and John Trumbull had been buried many years earlier. The older generation of patrons had followed Luman Reed and Samuel Ward to the grave. George Bruen, Robert Gilmor, Philip Hone, and Daniel Wadsworth were all dead. The voice of New York's first writers was fading out. James Fenimore Cooper died in 1851. The elderly Washington Irving watched the tracks of the first railroad to Albany being laid between his beloved home "Sunnyside" and the Hudson River's edge. Public attention had turned to New England writers. The poetry of Henry Wadsworth Longfellow and the stories of Nathaniel Hawthorne became popular. Ralph Waldo Emerson and Henry Thoreau became influential as Transcendentalists who believed that nature was evidence of God's handiwork, a view that greatly reinforced landscape painting.

New York City provided increasing opportunity for artists. The commercial art dealer began to fill the gap left by the Art Union's demise, helping the artist sell his paintings to a broader patronage. New patrons joined artists and writers in weekly meetings at the Century Club—still thriving today as the dynamic outgrowth of the old Sketch Club. As people began to feel hemmed in by the growth of the city, they became progressively fond of paintings of forests and mountains. Collectors began to vie for the best works of art, and artists were paid handsomely for their work.

Durand, now fifty-four years old, continued as the president of the National Academy. He, also, assumed the role of leading landscape painter. He had begun to take his oil paints—now conveniently stored in tin paint tubes (not invented until 1841) into the woods where he completed his sketches down to the last detail with the subject immediately in view. When he put down on canvas exactly what he saw before him, he was able to alter the rules of composition he had learned from his study of Claude Lorrain, and created paintings more expressive of the scenery around them. The most famous outcome of Durand's new method was a painting called "Kindred Spirits." It marked his first attempt to capture the true character of the American wilderness.

Jonathan Sturges had commissioned Durand to paint a landscape as a testament to Bryant and Cole's mutual efforts to awaken Americans to the beauty of their natural scenery. In "Kindred Spirits" the

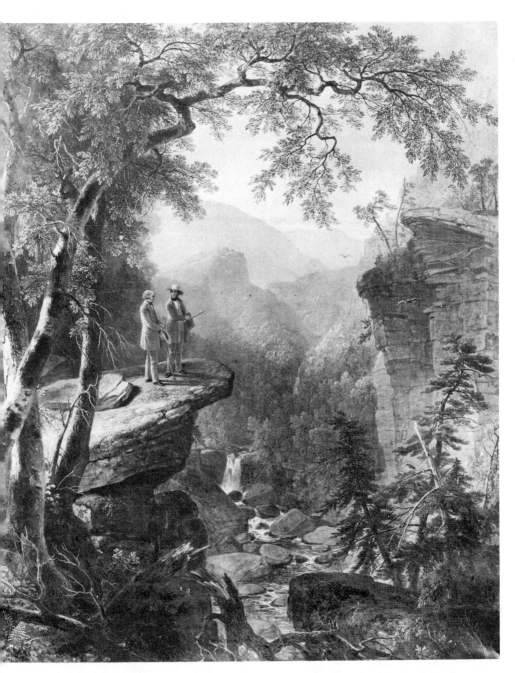

KINDRED SPIRITS by *Asher B. Durand. Collection of the New York Public Library, Astor, Lenox and Tilden Foundations.*

poet and the artist stand on a rock projecting over a stream that tumbles down from the distant Kaaterskill Falls. Wearing his painter's coat and carrying his red sketchbook, Cole directs Bryant's attention to the view. He seems to be engaged in his well-known "wood and field talk," as the poet, holding his walking stick and hat, listens intently. Tall trees arch in a great protective sweep over the small figures that appear dwarfed by the encompassing wilderness. A detail, hardly visible in the reproduction, bears witness to Durand's engraving career—their initials have been carved into the bark of the tree on the left. Sturges presented the final painting to Bryant.

Landscape, which had comprised only about one out of ten paintings in the National Academy exhibitions of the early 1840s, now began to dominate them. The younger landscape painters no longer suffered from the feelings of inferiority that had troubled Cole. They were reading books written by the famous English art critic John Ruskin, which destroyed the last trace of Sir Joshua Reynolds' argument that landscape was an inferior branch of art. Ruskin, through his praise of Turner, supported the significance of modern landscape painting. Freed by the general acceptance of his argument, the young landscapists were no longer restrained by the contradictions that crippled the earlier artists.

Many promising young artists had followed Cole and Durand's path into the Catskills, Adirondacks, and White Mountains. Durand's traveling companion, John Kensett, was bringing the beauty of the White Mountains back to a New York audience in paintings of tones of silvery gray. After spending a summer in the Catskills enjoying the "absolute freedom of the landscape painter's life," another young artist, Sanford R. Gifford, decided that he could never again return to the drudgery of portrait painting. Jasper F. Cropsey, who was later to specialize in autumn scenery, was exhibiting landscapes painted near his home on Staten Island. So many artists began to paint landscape that Henry T. Tuckerman, the art historian of the period, names as many as forty-five in his *Book of Artists*.

Singled out by critics as the most promising of the younger artists was Cole's pupil, Frederic Church. The first major painting produced in his Hartford studio was based on an event in which his ancestors had participated—a party of settlers under the leadership of

Reverend Thomas Hooker traveling from Plymouth, Massachusetts, to the Connecticut River Valley where they founded the town of Hartford. The final painting, "Hooker's Party Journeying Through the Wilderness," was composed in a formal, self-conscious style, but Church had made a shrewd choice of subject matter. A painting of the founding of Hartford could scarcely be ignored by the museum that Daniel Wadsworth had recently opened there. The painting was bought for $130, and it is still owned by the Wadsworth Atheneum today.

Church did not stay long in his home town. He needed to be closer to the center of artistic activities, so early in 1848 he moved to New York City. Almost immediately his teacher died. It came as a bitter shock, but Cole's death gave him impetus to fill the void left behind.

New York City offered Church many new interests. Early photography, called daguerreotype after its French inventor, Louis Jacques Daguerre, had been introduced into this country by Samuel F. B. Morse in 1839. Daguerreotype studios sprang up all along Broadway. Church immediately saw it as a tool that would help him render nature more accurately. Its sharp focus and ability to pick up every detail fascinated him so much that its influence was felt in his next major painting, "West Rock, New Haven." It depicts a view of a large, flat-topped rock that juts above the fields just outside of New Haven, Connecticut. The painting made the viewers feel that they were actually in the space. The sky and land stretched out on both sides. Critics noticed that it was as "accurate as a daguerreotype." It won the twenty-three-year-old artist membership in the National Academy, and it was purchased by a friend who later was to become famous as the promoter of the first transatlantic telegraph cable, Cyrus W. Field.

Cyrus Field was brought up in Stockbridge, Massachusetts, under the austere eye of his father, a Yale-educated minister. Although the Fields had intellect and distinction, they did not have money. The teen-age Cyrus was sent to work as an apprentice at the famous New York dry-goods store, A. T. Stewart's. His knack for salesmanship and his driving energy brought him quick advancement to senior clerk. Despite Mr. Stewart's urging him to stay on, he resigned to join his brother in the paper business in Lee, Massachusetts. Fred-

WEST ROCK, NEW HAVEN by Frederic Church. Courtesy New Britain Museum of American Art, John Butler Talcott Fund. Photograph by E. Irving Blomstrann.

eric Church's father also owned part interest in a paper mill in the vicinity, and during Frederic's trip there with his father, he met Field, who often joined him on Sunday painting expeditions. Church, a good businessman himself, was fascinated by Field's commercial skill, and Field was attracted by his friend's artistic talent. Field's ancestors had also been members of Reverend Hooker's party in the seventeenth century. He and Church, both tall, wiry, and well-bred, possessed strong, persistent and energetic personalities. They were supported by an inherited confidence, and driven by an imagination that dared conceive of the new and the untried.

Before Field was thirty years old he had gained success, wealth, and status as the owner of the largest wholesale paper firm in New York City. With his new fortune, he and his wife, Mary, decided to build a mansion on the exclusive Gramercy Park Square. The rooms were to be furnished with French furniture and the walls hung with landscapes of American scenery.

Church had completed a number of paintings of New England. He was now eager to turn his talent toward depicting the natural wonders of other parts of the country. The Fields, who were awaiting the completion of their new house, had never visited the southern states, so in 1851, Church and the Fields decided to take a trip together. One of the first places that Church set up his easel was at Natural Bridge in Virginia. As Church was painting, Field entertained himself by climbing the limestone cliffs to gather rocks so Church could obtain their exact hue. Church, however, refused to use them because he understood that the air and distance between the viewer and the rocks altered their color. The light also had changing effects. Church never spoke of his painting methods, but his work reveals that he was very much interested in atmosphere and time of day. Disappointed that his hard-won rocks were of no use to the artist, Field agreed to buy the painting only if the final color of the stone bridge matched his samples. It apparently came out to his satisfaction, as the painting hung in his new house for many years.

The travelers continued on to Mammoth Cave in Kentucky, and as far west as the Mississippi River. They returned home by way of Niagara Falls.

XI

The South American Adventure

Back in New York people were talking about a new publication recently translated into English, entitled *Cosmos,* by the German scientist, Baron von Humboldt. Humboldt was as famous in his day as Albert Einstein is in ours. He devoted his entire life to compiling in this five-volume work all the scientific facts that he could discover about the world. As a young man, he had studied botany, chemistry, astronomy, and geology. He then started out to investigate those places where he could best apply this knowledge. He was particularly attracted to Ecuador, where the natural phenomena abounded in great variety. In the final years of his life Humboldt described in *Cosmos* all that he had learned from nearly half a century of study and exploration.

As soon as *Cosmos* was published in English, the inquisitive Church plunged into the writings of the famous scientist. He read all that was known about the Milky Way, comets, vanished stars, the Aurora Borealis, the planets, sunspots, shooting stars, and other aspects of the universe. He read about earthquakes, volcanoes, hot

springs, animals, plants, and the different races of man. He learned of the interconnections between these phenomena, and how nature works as one great whole, moved and animated by internal forces.

Ecuador was the one place in all the world, Humboldt announced, where different climates, one ranging above the other according to altitude, could be observed at one time. "There at a single glance, the eye surveys majestic palms, humid forests," he wrote, ". . . then above these forms of tropical vegetation appear oaks and sweetbrier, and above this the barren snow-capped peaks . . ." He predicted that landscape painting would acquire an unknown brilliancy when artists dared to venture far in the interior of tropical continents.

At the same time that Humboldt's description of South America awakened Church to its artistic possibilities, Field was considering its commercial value. The idea of Manifest Destiny was at its height in the early 1850s. Some Americans believed that they were chosen by divine right to bring liberty and prosperity to the entire new world. They thought that the United States was destined to expand, not just to the Pacific, but to Canada, and to Central and South America. One strong advocate of Manifest Destiny, Matthew Fontaine Maury, was publishing a series of articles on South America in *The National Intelligencer*. He saw the great continent as a waste unless it was turned into a commercial venture. He imagined steamboats moving up and down the muddy waters of the Amazon River, its jungles replaced by plowed fields, and immigrants building towns on its banks. Maury's articles alerted Field, now retired from the paper business and looking for a new enterprise, to the potential wealth of this southern continent.

The artist and merchant shared their excitement about South America, and began to make plans to follow Humboldt's route through Colombia and Ecuador. Backed up by a faith that the vast and beautiful nature on this primitive continent would be entirely good to them, the two adventurers set sail from New York City in April 1853.

After twenty lazy days on the brig *Viva*, Church and Field arrived in Savanilla, Colombia, a seaport on the northern coast of South America. They planned to catch a steamer up the Magdalena River from the town of Barranquilla—still fifteen miles away. There were

no roads between one town and another; there were only bridle paths. The temperature was over one hundred degrees. The only transportation they could find was the skinniest, sharpest-boned horses they had ever seen. Exhausted from the heat and aching from the long ride, they finally arrived in Barranquilla. Their spirits were soon revived when they sat down to a dinner of roast chicken, boiled beef, beans, ham, fried plantains, rice, and a delicious new fruit for dessert—mangoes.

The next morning they discovered that they had missed the steamer and would have to wait ten days in Barranquilla for the next one. Having the opportunity to explore the old town leisurely, they pried into all sorts of things. Church examined the cactus growing taller than the trees, the wasp nests larger than bushel baskets, and the turkey buzzards strutting around the yards like chickens. He even sent his mother a cast-off skin of a scorpion, asking her to take careful notice of the curved sting in the tail. He showed her the size of some huge insects by drawing their outlines on his stationery. He sent home so many dried seeds that he asked his parents to build a greenhouse in order to plant them. Field explored the markets—pinching, tasting, weighing, and pricing the fruits. He visited the rubber forests and gold and silver mines. Sometimes he asked Church to make sketches of his interests.

On May 10, they boarded the steamer up the Magdalena River which would take them four hundred miles into the interior of the country. They ate only rice and chocolate at each meal, caught a huge tarantula in their cabin, and fought off stinging mosquitoes and aggravating sandflies. The steamer pushed against an eight-knot-per-hour current that grew stronger as the river narrowed. The passengers had to transfer to a canoe which was poled upstream as far as it could go. Finally, they were forced to go ashore, and made the final portion of their trip on muleback.

Neither Church nor Field had ever encountered such awesome nature as they saw on the four-day trip over the Andes into Bogotá. Paths seemed to wind endlessly upward. The air grew so thin that breathing became difficult. Sometimes the trail ran along the edge of a precipice, sometimes it turned into zigzag steps cut into rock, sometimes it disappeared altogether. The Indians sprang about the mountain paths like goats, but the two hulking Americans had to rely en-

tirely on the sure-footedness of their mules. With one misstep, mule and rider would plunge hundreds of feet to their death. The descent was equally treacherous. The mules' front hoofs slid on loose stones, hind hoofs lurched dangerously off the edge.

One evening, after their Indian guides and baggage had stopped far behind, Church and Field continued ahead in hopes of finding a suitable wayside hut in which to spend the night. Each mud hut they approached appeared so dingy and foul that they ventured on to the next, until they discovered that they had gone far beyond the last house. The night was black, and the mules were struggling along a steep, rocky path.

They made a safe descent and came out into a hot tropical forest. For a while, the mules wove in and out of loose vines and thick foliage. Suddenly, Church and Field realized that the path had been lost. Leaving Field behind with the mules, Church pushed his way on foot through the thicket in hopes of recovering the path. Not having any success, he climbed a tree, and from its top gazed into the black night looking for a light that could direct his way. The only flicker he could see was that of the stars. For a well-bred young man from Hartford, Connecticut, to be perched on the top limb of a tree deep in the Andean jungle seemed a ridiculous predicament indeed! Making a joke of his situation he decided to try bargaining in Spanish. At the top of his voice he shouted that he would give "cinco pesos" to anyone who would help him. There was no answer. Losing his Yankee thrift, he raised his price to ten, then twenty. The only reply came from the hooting and howling of wild birds and beasts.

He climbed down from the tree, and tried to make his way back to where he had left Field. Branches whipped him in the face, and perspiration ran down his chest. Suddenly, the ground seemed to fall out from beneath his feet. When he recovered from the plunge, he found himself sitting unhurt on the sandy bottom of a stream. The cool water was refreshing. He lay back and pretended that he was in a tub at home. Before long the night noises brought him back to reality. He tried to climb out, but the banks were too high and slippery, and at each attempt he slid back into the water. With the aid of a thick root, he finally managed to pull himself out, and shouting "halloo" all the way, he proceeded in the direction of where he thought he had left Field.

Finally, he heard a faint reply, and in a few moments he found Field, lying on the ground hardly able to speak, he was so ill with fever and nausea. He could go no farther. They made a bed of saddles and blankets, but in the dark they had placed it on top of an ant hill and were nearly eaten alive by tropical ants.

In the morning Field was still too sick to travel. Church left him behind to look for help. He met some Indians walking down the path, and inquired how far to Bogotá.

"Is it two leagues?" he asked.

"Sí, señor."

"Is it five leagues?" he asked again, to be certain they understood.

"Sí, señor."

"Is it eight leagues?"

"Sí, señor," they answered for the third time.

At long last he did arrive in Bogotá, where he found the home of an American to whom he had a letter of introduction. Before the day was over, Field had been retrieved and put into bed, and Church entertained his host with the story of his first adventure in the Andes.

The highlight of their stay in Bogotá was a side trip to the Falls of Tequendama, the subject of a famous landscape. They had hired an army of Indians to hack away the thick foliage with axes and machetes so Church could sketch a view as close as the spray would allow him. As he sketched, huge and gawdy macaws sailed in the air and bright rainbows appeared in the mist.

Church and Field spent the next six weeks riding four hundred miles over the Andes by muleback from Bogotá to Quito, in Ecuador. On the way they stopped to drink from the Vinegar River, which flowed from a volcano near Popayán. They tried making a little lemonade from its sour waters by simply adding sugar. "It was delicious," wrote Church, "with a fine flavor sufficiently charged with just enough acid to be agreeable."

As they followed the Andes south they saw the peaks soaring higher and higher until they reached the city of Quito, which sits in a basin surrounded by smoking volcanoes. The two mountains that Humboldt had praised so highly were located in this region: the 19,344-foot Cotopaxi, the world's highest active volcano, and the 20,577-foot Chimborazo, one of the world's highest mountains.

Church had hoped to be able to sketch them from every possible angle, but for lack of time, he could only make a few hasty sketches of them. It was the end of August; the journey had taken longer than they had planned, and Field was due in Stockbridge for his parents' golden wedding anniversary in October. The two adventurers hurried down the Rio Guayas to the town of Guayaquil on the coast of Ecuador, where they caught the steamer to Panama. Crossing the Isthmus of Panama by railroad, they took another steamer to New York City.

Still dressed in straw hats and ponchos, Church and Field returned exactly six months and twenty-three days after their departure. Parakeets screeched from their cages as their baggage was unloaded. Church's arms were full of branches of dried palms and other exotic plants. Field walked down the gangplank with a jaguar on a leash and a devilish Indian boy following behind.

Back in his Broadway studio, Church began painting with such energetic fervor that for the following three years he worked ten hours a day and rarely left New York even to escape the summer heat. Having found that his small South American views met with enthusiasm at the National Academy Exhibitions, he began a large painting measuring over six feet in width, which was to include all the grandest features of Ecuador.

Church's method of arranging compositions was to lay his sketches out on a large table. He then moved them about like pieces of a puzzle to see how they could best be combined into a full-sized painting. He worked slowly during this conceptual stage, but once he had decided upon the arrangement and had drawn the composition on the canvas, he quickened his pace. Beginning to paint from the upper left-hand corner, working downward and across, he was able to complete his painting with a rapidity and precision which utterly astounded those who saw him at work.

In the completed painting, "Andes of Ecuador," Church painted an Ecuadorian valley cut by a river which winds toward many distant mountain ranges. The snow-capped peak of Chimborazo rises on the left, and the smoking cone of Cotopaxi on the right. In the foreground, he painted a tropical rain forest thriving in a hot, humid climate; just below, a dry savannah with century plants, yellow grasses, and grazing llamas in a bleak, arid climate. No one had ever before

combined such a variety of climate and vegetation in a single view.

Church considered his painting as much a scientific effort as an artistic one. He conveyed not only the extraordinary beauty of this Ecuadorian valley, but the scientific facts unique to this particular region. One critic noticed that he could rely "on each plant as a veritable transcript . . ." and added, "for no matter how subtle the treatment of a picture, or how artistic its composition, if it had not this basis of truth, we are only polishing pebbles."

In Church's day viewing stereographs was as popular an evening diversion as watching television is in ours. People were fascinated with the three-dimensional effects produced by looking at a double photograph through a viewer—similar to the current-day Videomaster. Church's photographic memory enabled him to record nature with amazing accuracy, but he also made use of these commercial stereographs to validate the broad range of tropical vegetation he depicted in his paintings.

Church's cool, even temperament endowed him with the appropriate personality to satisfy the public craving for scientific exactness. Although he never imposed his personal feelings on nature, the mood of his times is consistently mirrored in his work. In "Andes of Ecuador" sunbeams bisecting a shiny plateau form a cross in the very center of the painting. Church may have painted this glowing cross unconsciously; nevertheless, it signifies that the people of his era considered the study of nature a religious occupation.

In 1857 when "The Andes of Ecuador" was exhibited at the National Academy, the critics felt that it "caught and conveyed a new feeling to the mind." Church had not just painted the many separate elements of nature, but had been able to compose them in such a way as to reveal the internal processes that created them. Critics called Church "the artistic Humboldt of the new world."

Whereas the South American trip had satisfied Church's most lofty dreams, it had discouraged those of Field. He concluded that the lack of communication between towns, hostility between countries, and the formidable mountain and jungle barriers made commerce impossible. The primitive beauty of the continent had inspired Church to new brilliancy. His South American landscapes brought him widespread recognition and made him the most famous artist of the mid-nineteenth century.

XII

Düsseldorf

The growing numbers of young artists in the United States were looking for ways in which they could find instruction in landscape painting. Drawing from ancient casts at the National Academy did not offer practice in the kind of art they intended to make their career. Copying engravings and drawing directly from nature provided them with the rudiments, but many longed to master more sophisticated techniques than they could teach themselves. So many more artists had applied to Durand for assistance than he could possibly help that he felt the necessity to publish letters of art instruction in an art journal. With the highly esteemed Thomas Cole dead, students turned to Church for advice before he himself had matured. Church was not a good teacher. He painted what he saw and he told his students to do likewise. After a winter with Church one pupil concluded that he "learned nothing worth remembering." With little to offer in art instruction in the United States, some young artists began to look toward Europe. The fame of the Düsseldorf artist Emanuel Leutze, who was German-born but American by upbringing, began to grow.

The art academy there also offered techniques that appealed to Americans who began to recognize Düsseldorf as one of the leading European art centers.

One of the more important artists who found his way to Düsseldorf was Worthington Whittredge, who was born in a log cabin on the Little Miami River near Springfield, Ohio, on May 22, 1820. As a young boy he worked on his father's 120-acre farm and was allowed only a few months of schooling each year.

Like most of the artists who turned to nature for their central theme, Whittredge had become familiar with the wilderness as a young boy. Beavers, muskrat, and otter were so plentiful in Ohio that he moonlighted as a trapper. Leaving his warm bed about midnight, he would tramp through the snow and sleet to inspect his traps, returning to the farm laden with pelts in time for the morning milking. He hoped that the money he made from selling the prized furs would pay for a high school education, but his father refused to allow him to leave his farm work. By the time he was seventeen years old, he had decided that he wanted to be an artist (although he had no idea from where the inspiration came). He did not dare tell his father, who thought that any man who spent his life dabbling with paints was a lost soul. Whittredge, nevertheless, was determined to leave the farm. Finally, when his brother returned home, he announced that he was going away.

With a new homespun suit, knitted stockings, and two dollars and fifty cents in his pocket, Whittredge started out for the home of his sister who lived in Cincinnati. He hoped that his brother-in-law would employ him in his house- and sign-painting firm. "Of course there is a gulf of many thousand miles between a house painter and a painter of pictures," Whittredge admitted in his *Autobiography*, "but somehow the gulf did not seem so wide to me at that time." To a boy of seventeen whose ambition in life was to be an artist, the prospect of handling paint and estimating color effects seemed very exciting. But after months spent crouched on the floor with a heavy brush in hand, painting baseboards, Whittredge began to hate the job. There was only one way out, and that was to improve himself so he could advance from house painter to sign painter. Each evening Whittredge copied letters out of books until he learned how to form them perfectly. He was then promoted to sign painter, and was al-

lowed to paint signs for boot shops, pictures on fire-hose wagons, and portraits of presidential candidates on banners.

After some years of painting signs, Whittredge found an opportunity to set up the first photographic studio in Indianapolis. It failed, and he went to Charleston, West Virginia, to try establishing himself as a portrait painter. He spent all winter painting the portrait of the pretty wife of a senator, who held him spellbound by her feminine wiles. He finally realized that he was wasting his time and, in disgust, he ripped apart the canvas and hopped a boat back to Cincinnati.

Enthusiasm for art had existed in Cincinnati even before the Art Union had set up a branch there in 1847. Whittredge made friends easily and became acquainted with local collectors who were delighted to have the young artist study their paintings. His early style was reminiscent of the work of Thomas Cole, whose paintings could be seen in local collections. In 1846 he sent "View on the Kanawha, Morning" to the National Academy. It was accepted for exhibition and he received a complimentary letter from Durand, then serving his first year as president.

Whittredge's work sold quickly in Cincinnati, and it was not long before he began to think about the possibility of studying abroad. Some local businessmen offered to help fund his trip, and by 1849 he was prepared to leave. Before sailing he spent a week in New York where the newspapers were full of reviews applauding the exhibition at the newly opened Düsseldorf Gallery. An exhibition of contemporary foreign art had not been seen before in the United States. "The Martyrdom of John Huss," by the famous historical painter Karl Friedrich Lessing, attracted the most attention, but critics were also enthusiastic about works by the gifted landscapist Andreas Achenbach, and the genre painter Johann Peter Hasenclever. Their exacting technique must have appealed to Whittredge as it did to many Americans at this time. The newspapers reported that some people thought all these works had been painted by a Mr. Düsseldorf, and marveled at the huge output of one artist. Critics and serious collectors, of course, recognized that they had been painted by a number of artists who shared a similar style.

When Whittredge arrived in Europe, he was still uncertain where he would study. He visited a group of landscape painters working just outside of Paris in the village of Barbizon. He described

them as "Kickers" or rebels against all pre-existing art. Neither their rebellious attitude nor their loose handling of paint appealed to Whittredge, and he rejected them in favor of the polished techniques taught in Düsseldorf.

Düsseldorf was a quaint old town on the banks of the Rhine, located in the western part of Germany, just east of the Netherlands in a province called Westphalia. Tall, gabled houses with latticed windows and projecting eaves lined its narrow cobblestone streets. Dappled sunlight played on the roofs of small Gothic chapels, and the parks were brilliant with flowering hawthorn, lilacs, and chestnuts.

Artists from many countries flocked to the famed Düsseldorf Academy of Art. Those who did not want to submit to its academic discipline were still attracted to the town's congenial artistic community. They learned from each other, freely visiting between studios, and enjoying lively discussions over cool pints of wine in tavern gardens. The frequent art exhibitions, the friendly artists, the charming people of the Rhineland, and the beauty of the countryside made it an ideal place for artists to acquire their training.

Whittredge hoped to escape the drudgery of drawing from plaster casts in the classes at the academy by being accepted in the studio of one of the prominent Düsseldorf artists. Andreas Achenbach, whose work he had admired in New York, would have been the most desirable teacher, but Achenbach did not take students into his studio. He thought it would result in artists copying him rather than developing their own styles. Whittredge decided that if he could entice Mrs. Achenbach to rent him her spare room, he might be in an advantageous position to receive comments on his work from her husband.

It had been relatively easy for Whittredge to make the acquaintance of some of the notable artists of Düsseldorf because his Cincinnati patrons had commissioned him to purchase their works for their collections. Placing himself on familiar terms with the Achenbachs, however, required extra effort and ingenuity. To get on the right side of the lady of the house, he studied his German harder than ever and sent to America for a present of American invention still unknown in Germany. When the crate arrived, out of it came a chair, "without a scratch, shining and beautiful," Whittredge re-

called. Having set it on the floor, Mr. and Mrs. Achenbach were baffled at its incessant rocking. "Can't the thing stand still?" they inquired. "It was not intended to stand still," Whittredge assured them. "It was intended to sit in at ease and rock gently back and forth." The Achenbachs shook their heads, covered their eyes, and refused to sit in it. Merely looking at the rocking made them dizzy.

Despite the unfortunate gift, Whittredge was allowed to rent the Achenbachs' garret room under the condition that he was not to enter Achenbach's studio without an invitation. He summed up what must have been a disappointing experience as follows: "I walked on tip-toe past his studio for an entire year without once going in." The only comment Whittredge was ever to receive when the master looked at one of his paintings was simply, "Sehr gut."

After giving up on Achenbach, Whittredge turned to Emanuel Leutze for advice. Leutze, who was the prime attraction there to American students, was an energetic, generous fellow with long hair and a mustache. The day Whittredge appeared at his garden studio, he found him in a long painter's robe with a little cap on his head, and a pipe reaching nearly to the floor. He was contemplating a giant-sized canvas to which he had just finished transferring a smaller sketch. It was a painting of "George Washington Crossing the Delaware." For accuracy, Leutze preferred Americans as models. Whittredge's arrival was a godsend, and it was not long before he found himself posing in an exact copy of Washington's uniform. He stood with one hand clasping his cloak, the other on his knee, for two hours without moving, to allow Leutze to paint the folds exactly as they were first arranged. After it was over, Whittredge was nearly dead, but Leutze poured champagne down his throat and he was revived.

Whittredge was a tall man with heavy-lidded brown eyes. His dark complexion, prominent nose, and full beard made him look so much like a Spaniard that Leutze felt impelled to pose him for a portrait in a Spanish nobleman's costume. He was handsome despite the receding hairline which had afflicted him ever since he was a young man. On his arrival in Düsseldorf, he had his baldness well hidden beneath a toupee. Feeling more self-confident after a few years in Europe, he decided it was time to reveal the secret that he had concealed from even his most intimate friends.

After much wine and fun at a Fourth of July celebration during

a summer sketching trip, he was given an amusing opportunity to rid himself of his hairpiece. A German girl in the party inquired about the American Indian practice of scalping their victims. The moment called for a demonstration. Whittredge abruptly seized a knife, gave a war whoop, climbed a nearby tree, and, hanging from a branch by his legs, to all appearances sliced his hairy scalp from his head and threw it to the ground. Three girls fainted, but Whittredge never again had to wear the toupee.

Whittredge and Leutze became good friends, and Whittredge moved into the same building. He had been working there four years when, one day, in walked a good-looking but very despondent young man. He introduced himself with a quick bow as Albert Bierstadt. He had come to Düsseldorf to visit his cousin, the genre painter Hasenclever, but discovered that he had recently died. He now turned to Whittredge and Leutze for help. He had been born on January 7, 1830, near Düsseldorf, but had grown up in New Bedford, Massachusetts. His father worked as a cooper, supplying barrels in which whale oil was stored and shipped. After school Bierstadt had helped in a frame-maker's shop. He began to do some painting himself, and was able to make his living by teaching art. Leutze's painting "George Washington Crossing the Delaware" had caused a great stir when it was exhibited in the United States, and Bierstadt had then decided he wanted to study with the master. He had been able to raise funds for his trip from helpful businessmen in New Bedford, but the unexpected death of his cousin had left him without money or friend. Leutze offered to look at the sketches he had brought with him, but he judged them "absolutely bad." After Bierstadt left, Leutze shrugged his shoulders and grumbled, "Here is another waif to be taken care of."

Whittredge offered Bierstadt use of his studio, and allowed him to spend the winter copying sketches. Whittredge observed that Bierstadt refused all dinner invitations, especially if it looked as if one had to be given in return. He had no money to spend on beer and wine. He preferred to be thought unsociable rather than impoverish himself by giving expensive dinners.

When April came, he gathered up his paintbox, stool, and umbrella which he put with his clothing into a large knapsack, and started off to try his luck among the Westphalian peasants where he

expected to work. Whittredge heard nothing from him all summer. In late autumn he returned loaded with studies of oaks, roadsides, meadows, glimpses of water, exteriors of Westphalian cottages, and one very fine study of sunlight on the steps of an old church. Whittredge thought it was a remarkable summer's work for an artist who had had little instruction. Back in Whittredge's studio Bierstadt worked his studies up into large canvases. He worked from sunrise to sunset, and even Leutze had to agree that he had proved his independence, his perseverance, and finally, his talent for painting.

Bierstadt's improvement as an artist occurred so suddenly that New Bedford citizens could not believe that he had painted the European scenes which he sent home for sale. Rumors that Bierstadt had forged his name to paintings had grown to the extent that a local editor published an article claiming that Bierstadt's printings had actually been done by Leutze and Whittredge. When the slanderous news arrived in Düsseldorf, Bierstadt's friends were outraged. Leutze and Whittredge immediately drew up a paper that stated that the pictures were the genuine work of Bierstadt, and praised his ability as an artist. When Leutze told the story to his friends, Achenbach and Lessing, who were conversing over their mugs of beer that evening at the artists' club Malkasten (Paintbox), they insisted upon adding their signatures to the document. What at first appeared to be harmful to the artist proved in the long run to be helpful; the document with three great German names supporting his talent was printed in the New Bedford newspaper. Local citizens responded to the publicity by enthusiastically purchasing the paintings Bierstadt sent home. He began earning enough money to travel about Europe pursuing his studies, and enjoying the camaraderie at the Malkasten, a name which he was later to give to his elaborate mansion overlooking the Hudson River.

Whittredge and Bierstadt became good friends, rambling through the mountains together on sketching trips. In Switzerland they ran into Sanford Gifford walking along Lake Lucerne. Whittredge had met him for the first time some months earlier during his stay in Düsseldorf. Gifford had already been elected a member of the National Academy before he departed on what he described as his "pilgrimage" to Europe. He was a tall, lanky man of thirty-three

years, with curly brown hair and dark, sulky eyes. He had a thin, sharp face, and a long, fast gait that enabled him to cover over thirty miles a day on foot. His well-to-do background showed in his composed, aristocratic bearing. He had grown up in Hudson, New York, just across the river from Thomas Cole's home in Catskill. His father owned a successful iron refinery. He was the only member of the group who had any college education, having attended Brown University for two years.

Gifford was delighted to be invited to join Whittredge and Bierstadt in Rome, where they decided to spend the winter of 1856–57. They spent much of their leisure time together, and Whittredge tells the story of their visit to the village of Nemi on Lake Albano, southeast of Rome. There was only one very old inn in the village, which had only one bed that was celebrated for its enormous size. Four men, Bierstadt, Whittredge, Gifford, and another artist had to spend the night in the famous bed. Two of them slept abreast facing in one direction, two abreast facing in the other direction. Only the shortest member of the group was able to get a good night's sleep.

In the spring, Bierstadt and Gifford took a trip to Naples and Capri, but one winter in Rome was enough for both of them. Leaving Whittredge behind, they returned to the United States in the autumn of 1857.

XIII

Church's Fame Spreads

In 1857 when Bierstadt and Gifford returned to New York, interest in the arts was exploding. Exhibitions of all kinds were being held. Since the opening of the Düsseldorf Gallery, now housed in a domed marble building with an elaborate sculptured façade, European and contemporary art had begun to flourish alongside of native painting. As many as six private art dealers were actively selling European and American painting in the city. The Parisian firm Goupil (the present-day Knoedler) held frequent exhibitions of contemporary French art. New York artists felt so confident in the increasing sales of their own work that they opened the National Academy Galleries to an exhibition of two hundred works of contemporary British painting—many embodying Ruskin's theories. New Yorkers could see private collections of Old Masters on special visiting days, and had free access to the public galleries that now housed the famous allegories of their own pioneer landscape painter. On the corner of Second Avenue and Eleventh Street in the New York Historical Society's new building, Cole's "Course of Empire," with the rest of Luman Reed's

collection, was on permanent view. At Fifth Avenue and Thirty-fourth Street, a girls' school, called the Spingler Institute, had a free gallery where "The Voyage of Life" provided the main attraction. It had been purchased from the Art Union winner by the school principal, Rev. Gorham D. Abbot, to encourage a correct moral attitude among his students.

Openings of art exhibitions had become important social events. Gentlemen donned their silk hats and swallowtail coats as ladies wrapped themselves in their stiff crinolines and white shawls to attend these artists' receptions. The traditional all-male dinner that had preceded the National Academy's annual exhibition was discontinued in favor of formal receptions to which ladies were invited. At these gala events the public could peer at the paintings, meet the artists, chat with their friends, and make new social acquaintances to the melodious strains of concert music. Although their receipts were moving slowly up to their old-time high, the National Academy had not yet been able to afford to move into their own building. They held their receptions in a new building on Fourth Avenue and Tenth Street, where their rented space was attractively carpeted and brilliantly lit with gas jets. Art was becoming so highly prized that newspapers reported the robbery of as many as thirteen works of art from an exhibition and announced that stolen paintings were on the increase.

American artists continued to depend heavily on the National Academy Exhibitions to give exposure to their work. In 1857, Church had shown there his first South American masterpiece, "The Andes of Ecuador." Kensett exhibited regularly seven or eight serene, pearly-hued landscapes. Jasper Cropsey sent vividly colored views of American scenery from his London studio. The elderly Asher Durand was exhibiting his most original contribution to landscape painting at this time. It was entirely new to exhibit "studies" as finished works of art. It was also new to complete a landscape outdoors rather than working up a more formal composition in the studio. Durand's small, close-up views of nature—such as "Wood Interior" in which the design is determined by what he saw rather than a preconceived arrangement—are considered today some of his finest work, and were purchased enthusiastically by the public of his time. By 1858 Gifford offered as many as eight soft, hazy landscapes and the following year Bierstadt's crisp, forceful work appeared on view. Among the works

of the up-and-coming leaders of mid-nineteenth-century painting, appeared the fresh green views of George Inness. Although he had been an associate member of the academy since 1854, his work was ignored for decades until, late in life, he made radical changes in his style that brought him widespread popularity.

Many lesser-known artists sent in landscapes that conformed to a distinct style. Critics began to realize that the dreams of the earlier arbiters of national taste were coming true—that finally a national school of landscape painting had been formed. Because the inspiration of so much of the work came from the upper Hudson River Valley, they coined the native painters of landscape the Hudson River School.

For years Durand had had occasions to talk about art—first on his rambles through the woods with Cole, and later, during his summer excursions with his students to Lake George and the Adirondacks. Art had provided the main topic of discussions at the Sketch Club, and later, Century Club meetings. Young artists rallied around Durand's roomy Amity Street studio to talk about the goals and principles of landscape painting. After many years of formulation, certain recurring ideas began to take shape in Durand's mind.

In 1855, Durand's son, John, and one of Church's disappointed pupils, J. W. Stillman, began to publish an art journal called *The Crayon*. They persuaded Durand to write on the subject of landscape painting. He composed his essays as a series of letters to a young artist. Today these are unique as documents formulating the concepts of the Hudson River School. In his own time they served to clarify the mission of the artist, and to teach the proper techniques for carrying it out. The highest aim of the artist, Durand believed, was the imitation of nature. Nature was "fraught with high and holy meaning," and any alteration of it by the artist, he reasoned, would offend the Divine Spirit that created it. These views were not revolutionary. They supported the theories in which Emerson and the other Transcendentalists believed, and they clarified in the American mind what people had already read in Ruskin's popular *Modern Painters*.

Artists no longer considered imaginative landscapes worthier of their efforts than scenes of actual places. The goal of the artist, Durand wrote, "is not seen as creating an imaginary world, but in revealing the deep meaning of the real creation around and within us." Nature no longer was supposed to be spruced up with ruins and

moral lessons. The beauty of nature depicted on canvas was itself sufficient.

No one was better situated to fulfill this mission than the American artist, Durand believed, because this continent offered the purest form of nature. The primitive wilderness provided the artist with unparalleled means for depicting nature as it might have been found at the time of creation. Durand convinced his readers that America's isolated lakes, empty prairies, remote valleys, and unexplored mountain ranges, guaranteed the artist a reputation of originality that he could not find elsewhere.

There was little opposition to these ideas in the mid-1850s. The artists appeared to be in perfect harmony with their times. The widespread acceptance of art coupled with the rising economy created a demand for landscape painting that had never before occurred in the United States. Riding on the crest of this wave of enthusiasm was Frederic Church, whose canvases more than any others revealed an awareness of God in nature to an audience that instantly responded to the message.

After the success of his South American scenes, Church had decided to look to his own country for further challenge. Every landscape painter of the century had tried to capture the grandeur of Niagara Falls on canvas, but no one had been able to convey more than a weak interpretation. Church made two visits to Niagara in the spring and summer of 1856. In order to catch a view of the falls in their entirety he had to climb a tree, cut away interfering foliage, and make sketches as he balanced precariously on a limb.

One of the new art dealers, Williams & Stevens, bought the completed painting for twenty-five hundred dollars and paid two thousand dollars more for the copyright to reproduce it in color lithographs. "Niagara" was the first painting to be exhibited as a single attraction in a dealer's gallery, and people by the thousands paid their admission fees to gaze upon this painting of America's greatest natural spectacle.

In "Niagara" the falls are viewed at such an elevated angle that the modern observer feels himself to be flying over the roaring torrents in a helicopter. Church could not draw upon any traditional methods of composition to depict the boundlessness of space that confronted him. He disregarded the usual confining foreground trees

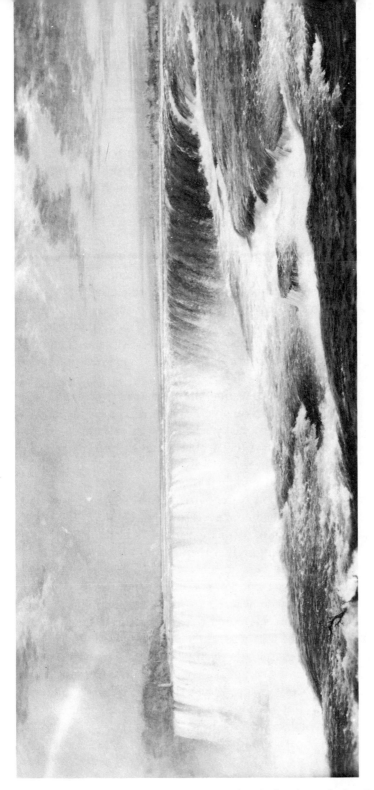

NIAGARA by Frederic Church. In the Collection of the Corcoran Gallery of Art, Washington, D.C.

or rocks to allow the waters to flow unimpeded from one side of the long canvas to another. He also chose an unusual size of canvas, seven feet long, but only three feet high.

The view appears to be Horseshoe Falls seen from the Canadian shore, but the final painting is really composed from sketches taken from a number of views. They are combined in such a way to convince the spectator that he is standing before the very sight.

The droplets of spray, the rock beneath the swirling waters, and the rainbow are painted with meticulous care, but Church went further than portraying only the simple reality of a scene. He was able to convey the sheer weight and energy of the plunging waters. One critic interpreted the force of the waters as representing the "onward march of civilization." By expressing the vitality of the times, whether it was the flow of water or the flow of people migrating to the West, Church had made "Niagara" a national symbol. The critics found it "incontestably the finest oil picture ever painted on this side of the Atlantic."

Church's method of delineating the motion of water appears to have been influenced by Ruskin's description of the arrangement of curved lines in water "perpetually changing from convex to concave." He also seems to have been able to take Ruskin's advice to "reproduce the experience in nature." By the summer of 1857 "Niagara" was on exhibition in London. When Ruskin saw it, he discovered "an effect of light upon water" that he had waited for years to see in a painting. Church had conveyed so perfectly the reality of the rainbow that Ruskin mistook it for the reflection in the glass through which he viewed the painting, rather than part of the picture itself.

Having been able to paint a rainbow with such dexterity as to fool the most renowned art critic of the times, Church was now beset by eager young artists who wanted to learn his technique. Church was not an articulate man. He could not explain the talent that came so easily to him. His manner was stuffy and restrained, and his attitude toward art often exasperatingly flippant. His curt instruction to his young followers, however, may have come less from arrogance than his tongue-in-cheek humor. When they asked him to comment on painting, he was known to have replied, "Grasp nature in one hand and do what you like with the other."

As the public raved about "Niagara," Church was boarding a

steamer to return to South America. He was accompanied by Louis R. Mignot, a South Carolina artist living in New York, who was also interested in collecting new material for his landscapes. They sailed all the way down the west coast of Ecuador to the seaport of Guayaquil, then took a boat up the Guayas River to the village of Guaranda, which was situated only ten miles from the summit of Chimborazo. Church evidently had a very definite goal in mind. During his first trip he and Field had passed through this region hurriedly. In his first South American masterpiece, "The Andes of Ecuador," he had only been able to show Chimborazo and Cotopaxi as faraway peaks lifting above layers of mountain ranges. Now, his sketches reveal that he intended to capture these famed mountains from a close-up view. He did dozens of pencil sketches from every possible angle, and wrote extensive notes describing color effects.

From Guaranda, Church and Mignot traveled north, stopping to make sketches of Cotopaxi, on their way to the capital, Quito. They made a special expedition into the wildest regions of the Andes to sketch the erupting volcano Sangay. Church noted in his diary that their food consisted mostly of guinea pigs and potatoes which they peeled with the sharp shoulder blades of their little roasts. After about ten weeks, they were ready to return home.

In the spring of 1859, Church opened up his studio for the exhibition of his long-awaited masterpiece from his second trip to South America. He had carefully arranged the room to give the painting the most dramatic effect. He had darkened the room and arranged the chairs in rows like a theater. The large painting (one of his eight-footers) was hung against black crepe curtains and brilliantly lit by clusters of gas jets concealed behind silver reflectors. The frame was designed to give the painting the appearance of being a large picture window that overlooked an Ecuadorian valley dominated by the bulging, snow-capped peak of Chimborazo.

The newspapers were quick to discover this dramatic event. *The Christian Intelligencer* found that there in a "single focus of magnificence" was a "complete condensation of South America—its gigantic vegetation, its splendid Flora, its sapphire waters, its verdant pampas and its colossal mountains." Other newspapers were filled with column after column of descriptions. Hundreds of people willing to pay the twenty-five-cent admission fee flocked to see the

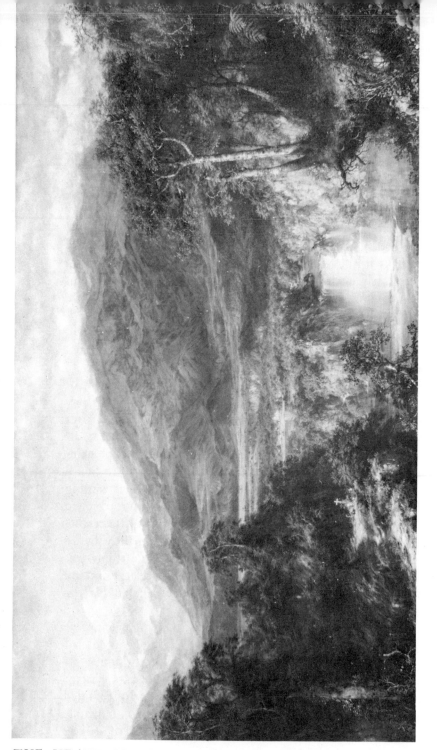

THE HEART OF THE ANDES by Frederic Church. The Metropolitan Museum of Art, Bequest of Mrs. David Dows, 1909.

painting. Crowds waiting at the entrance grew so large that they blocked the street and police had to be called to keep them in line.

Booklets describing the painting were available for sale at the door. Cole's biographer and Church's friend Reverend Noble, wrote a twenty-four-page description. Another friend, the writer Theodore Winthrop, composed an essay twice as long. These booklets served as travel guides for people "taking a trip" through the painting. They sat for hours scanning the surface through paper tubes. One eminent visitor, the writer Mark Twain, observed: "I have seen it several times, but it is always a new picture—*totally* new—you seem to see nothing the second time which you saw the first." Through his opera glasses he could examine the wayside flowers and count the leaves on the trees. Even the tiniest object had a distinct personality. By his third visit he found his "brain gasping and straining with futile efforts to take all the wonder in—and understand how such a miracle could have been conceived and executed by human brain and human hands."

Washington Irving, in the last year of his life, marveled at its "grandeur of general effect with such minuteness of detail." Ralph Waldo Emerson described it as "a fairer creation than we know." "The Heart of the Andes" had become the most celebrated American painting of the entire nineteenth century.

Church had painted another symbol of his age. He had interpreted the famed mountain peak—already regarded as nearly sacred by Humboldt's readers—and its tropical valley as a Garden of Eden. By painting the unspoiled land as a place of infinite untrodden beauty, he had perfectly expressed what *The Crayon* had advocated as the artist's mission—"to restore the landscape to what it was at Creation."

Worthington Whittredge was still living in Rome when he heard the startling news of Church's huge success. He had been breakfasting at the popular artists' gathering spot, the Cafe Greco, when someone brought in a copy of the New York *Herald*. It reported that "The Heart of the Andes" was bringing in six hundred dollars a day and crowds were so dense that many could not find standing room. The news, according to Whittredge, resounded "like a bombshell in Camp."

Two years had passed since Bierstadt and Gifford had left

Rome. Whittredge's European paintings had been selling so well in Cincinnati that he had been able to remain abroad longer than artists not so well supported by their communities. Whittredge had become addicted to the leisurely Roman life. He had taken dancing lessons so he could enjoy the balls given by the American ambassador, and paid his five *scudi* to attend the annual reception at the Palazzo Doria where the aristocracy came dripping with diamonds, medals, and gold braid. He had passed many pleasant hours sitting at the Cafe Greco drinking *caffé latte* in the long, narrow room called the Omnibus, imagining that the men sitting about him were either great or intending to become great. Occasionally a celebrity actually appeared, and Whittredge remembered the excitement aroused by the entrance of the pre-Raphaelite painter Frederick Leighton. Once he recognized Nathaniel Hawthorne, who was working on his book *The Marble Faun*, and met occasionally at parties the English poets Robert and Elizabeth Browning, who were both shy but "very great."

Rome had provided many happy moments, but after hearing the news of Church's success, Whittredge was no longer at peace with himself. It was immediately evident to him that Church had become the rage of New York City while he—Church's elder by six years—was still lingering in Europe. Feeling outdone by his colleagues in America, Whittredge immediately booked passage on the fastest ship of the time, *The Vanderbilt*, arriving in New York in eleven days.

"The Heart of the Andes" had already left New York to be exhibited in London in a gallery on New Bond Street. The English response was immediate. The *Daily News* wrote, "Turner, himself, in wildest imagination, never painted a scene of greater magnificence." Never having been to Europe, Church had planned to accompany his painting to a number of continental cities. He was particularly eager to make arrangements for it to be shown in Berlin, the home of Baron von Humboldt, but the aging scientist died that very year. Church's plans to accompany the work never materialized and the painting was never exhibited on the Continent. Church had become distracted by other matters.

When "The Heart of the Andes" had been exhibited in Church's studio, he had been known to hide behind the heavy curtains listening to comments, and sometimes peeking out at the specta-

tors through opera glasses. One day he had noticed a beautiful young girl accompanied by his friend Lockwood de Forrest. His shyness vanished and he rushed out into the crowd to greet them before they departed. The thirty-six-year-old artist, in his sideburns and gray smock, was immediately smitten by the tiny, perky girl who was introduced as Isabella Carnes, Lockwood de Forrest's cousin. Her slight accent betrayed her years of schooling in France as the daughter of the United States naval attaché. Isabella was charmed by the artist's refined but playful manner, and before "The Heart of the Andes" returned, they were engaged, and the following year they were married.

Having shown the public the most spectacular valleys and mountains of the Andes and the roaring cataract of Niagara, Church continued to search for new material. Responding to public interest already stimulated by expeditions to the Arctic, he set out to paint icebergs with his friend Rev. Louis Legrand Noble, who described the expedition in a book entitled, *After Icebergs with a Painter*. When Church's completed painting, "The Icebergs," was exhibited, the public saw a vision of pure heaven. The icebergs, like iridescent nuggets, reflected gold in the sunlight and emerald green in the crevices. The weird shapes and wild color depicted in the painting would today find a parallel in modern psychedelic art. Church's search for new subject matter had become so extensive that one critic suggested, "If visits to the constituent members of the solar system were practical, we are not certain but that Mr. Church would undertake to delineate Mars and Jupiter with their attendant satellites."

XIV

With Dew on Our Faces

Whittredge was forty years old when he returned to New York. Few traits of the farm boy who had left Cincinnati ten years before remained. He stood, tall and handsome, his thick black beard contrasting with his shiny bald pate. He had adopted a courtly manner well suited to the bubbling social world that had become so much a part of the New York artist's life.

Eager to refresh his mind with American paintings, he went immediately to the new building of the New York Historical Society. He entered a large room with two tiers of upper galleries supported by pairs of Corinthian columns. Gilded leather volumes were stacked in alcoves with elaborate white and gold railings. Old gentlemen in arm chairs studied huge portfolios on center tables that also served as pedestals for statuary.

He walked quietly over the patterned green carpet up the broad iron staircase to the third gallery where he found landscapes of Cole and Durand among the numerous portraits on exhibit there. He carefully studied the five paintings of Cole's "Course of Empire." He

disliked the allegorical subject matter and was disappointed that there seemed to be nothing American about the landscape. Cole's rugged brushwork, he observed, surpassed that of any masters of the past. Durand's landscapes overwhelmed him. He found them to be such faithful reproductions of American hills and valleys that they brought tears to his eyes. He realized what difficulty he was going to have forgetting foreign landscapes. If he was to succeed in this country, he would have to produce paintings that were "new and inspired by home surroundings."

Whittredge was tempted to move back permanently to Cincinnati, where he had so many friends, but he realized that New York offered the best opportunity for exhibitions and sales. The leading landscape painters had moved to the artists' studio building which had recently been completed at 15 West Tenth Street. It was one of Richard Morris Hunt's earliest buildings. Hunt was later to become famous as the architect for the fabulous Vanderbilt mansions, "The Breakers" in Newport, Rhode Island, and "The Biltmore" in Asheville, North Carolina. Gifford, Bierstadt, and Church were well ensconced in the new building—the first of its kind in America. It had twenty-five light, airy studios heated by coal stoves, and a large, domed exhibition hall on the first floor. Space in the building had been in great demand since its opening in 1857. With the exhibition there of Church's "Heart of the Andes," its reputation had been firmly established as the working place of the most eminent artist in the country. Whittredge was lucky to find an available studio. He paid his rent in advance to reserve it, and then departed for a short visit to Cincinnati.

Sanford Gifford had been one of the first artists to move into the Tenth Street Studio Building. His top-floor studio contained only a few wooden chairs, an easel, a small bookcase, and a mahogany table on which he kept a vase with a single rose in it. Gifford disliked clutter. After he had read a book, he gave it away; after he answered a letter, he burned it; and after he wore out a suit he gave it to the poor and bought himself a new one. He was as adept at concealing his college education as his inherited wealth. When he talked of painting, which he loved to do, he was careful to use simple, straightforward

words rather than the foreign terms that peppered the conversation of more showy artists.

What Gifford gained from simplicity, Bierstadt gained from elaboration. Indian relics of all kinds cluttered his studio—beads, arms, skins, war shields and feather headdresses. Stacks of stereographs were piled on the table near a viewer. Covering the walls between the artifacts and trophies were oil sketches of wagon trains, Indian encampments, moose, and bear. There were landscapes of mountains and winding rivers, stormy skies and sunsets.

Bierstadt had spent the first years on his return from Europe in New Bedford trying his hand at a variety of subjects—some landscapes of Westphalia, a historical scene of the founding of New Bedford, a genre scene of a fishmarket in Rome. These paintings sold well, but had not attracted notice from the critics. The fame of Church's "Niagara" had persuaded him that America's natural scenery was the only kind of subject matter worth pursuing. He spent a summer in the White Mountains, but found too many artists under their white umbrellas. The ambitious New Bedford artist wanted to paint scenery that had never before been seen by the public. Tales of the spectacular beauty of the West appeared in expedition reports, newspapers and novels. Many years before George Catlin had painted the quickly vanishing Indians, but no artist whose talent was equal to the task of capturing their splendor had attempted to paint the Rocky Mountains.

Bierstadt looked for a way to attach himself to a government expedition. Colonel Frederick W. Lander, explorer and civil engineer who had been West a number of times to survey alternative routes for the Overland Trail, was making arrangements in Washington to make another trip. Since the Mountain Meadows Massacre of 1857, when some Mormons had been responsible for the death of 128 Arkansas emigrants, the Overland Trail had been rerouted to the north. Lander had surveyed the new route, and in the spring of 1859 was employed to make improvements along it.

Bierstadt arranged to meet President Buchanan's Secretary of War who wrote a letter of introduction that helped him secure a place with the government expedition. On April 15, 1859, he and a

Boston artist, F. S. Frost, boarded a train to the West. Twelve days later they stepped off at the river town of St. Joseph, Missouri. The railroad tracks ended there. West of the Missouri River lay the Great Plains and the Rocky Mountains.

St. Joseph was a busy frontier town full of emigrants, land sharks, miners, and prospectors bound for the Pikes Peak gold fields. Brick and wooden stores lined the main street. Red letters on protruding signs identified a land office, printing shop, bank, gambling house, and saloon. Advertisements of cheap land were plastered over the store fronts. Raucous men with hard faces and gun holsters gathered outside the saloons. Clerks tilted their ladder-back chairs outside their stores, watching the wagons, carts, and horses clatter and rumble up and down the dusty street. The one hotel in town was charging two dollars a night for a few square feet of floor space. Bierstadt and Frost spent their nights rolled up in their blankets and sleeping sacks along with the frontier ruffians on the hard floor.

The artists discovered that as many as fifty to one hundred men were applying to the popular Lander Expedition each day. By May 5 Lander had picked up enough men and supplies to begin his journey West. Outfitted in blue flannel shirts, heavy pants tucked into their boots, slouch hats, and revolvers, Bierstadt and Frost mounted their horses with their paints, paper, and stereographic equipment following in the wagon train. They followed the south bank of the Platte River across what is today the state of Nebraska until it divided into the north and south forks. At the crossing they ran into hundreds of destitute and deluded gold-seekers returning home.

Bierstadt brought out his pad and pencil. Seated on the tongue of a wagon with his pad propped against a vinegar keg, he sketched scenes that later were to be published in *Harper's Weekly*. Both banks of the river were lined with the wagons and animals of the emigrants—some had safely crossed the rushing river, others still had to prove their endurance. As the wagons rolled into the river, water rushed over the spokes of the wheels, mules began to kick and plunge, the teamsters shouted and cursed. The crossings were dangerous. Horses and mules were lost, goods were swept downstream, and sometimes people were drowned in the torrents. Watching the activity were a band of Sioux Indians. Their chief, Dog Belly, sat in a circle smoking a peace pipe near Colonel Lander's wagon.

After safely fording the river, the Lander Expedition followed the North Platte River into Wyoming. Then they picked up the Sweetwater River, until they came to the South Pass. Many emigrants had made their way over South Pass seeking a better life and more fertile lands in California and Oregon. The road the Lander party followed was lined with ox skulls, broken wagons, stoves, and other household apparatus that had been discarded to lighten the wagons for the steep pass. Noonday stops provided Bierstadt with time to sketch these details that he later put together in a painting called *The Oregon Trail*.

The Lander Expedition settled for the summer just over South Pass in a valley between the Wind River Mountains and the Wyoming Range. The wagons were formed into a corral with earth embankments piled up as a bulwark against Indian attack. Lander's men cleared trees, rocks, and built reservoirs to hold water from small springs. The artists were not allowed to venture alone very far from the wagon train. Bierstadt reported that although the Indians had been kindly disposed to them, it was risky "because being very superstitious and naturally distrustful, their friendship may turn to hate at any moment." The valley lay at the headwaters of the Green River and within sight of the 13,730-foot Fremont Peak. It was as beautiful as any Bierstadt had ever seen, and he did many sketches of the area.

The Crayon kept New Yorkers posted on Bierstadt's travels by publishing a lengthy letter from him. "I am delighted with the scenery," he wrote. "These mountains are very fine; as seen from the plains they resemble very much the Bernese Alps. . . . They are of granite formation, the same as the Swiss mountains, and their jagged summits covered with snow and mingling with the clouds present a scene which every lover of landscape would gaze upon with unqualified delight." Bierstadt had not relied entirely on his pencil and paints to capture the grandeur of the West; he had also brought with him a stereoscopic camera. He discovered, however, that Indian subjects were better suited to the photography than scenery. "We have a great many Indian subjects. We were quite fortunate in getting them, the natives not being very willing to have the brass tube of the camera pointed at them. Of course, they were astonished when we showed them pictures they did not sit for; and the best we have taken have been obtained without the knowledge of the parties. When I am

making studies in color, the Indians seem much pleased to look on and see me work; they have an idea that I am some strange medicine-man."

At the end of the summer Bierstadt, Frost, and a man in charge of the animals had left the Lander Expedition, which was to continue on to California. Bold and hardy, Bierstadt appeared to enjoy the dangerous journey homeward. He wrote, ". . . we go wherever fancy leads us. I spend most of my time in making journeys in the saddle or on the bare back of an Indian pony. We have plenty of game to eat, such as antelope, mountain grouse, rabbit, sage-hens, wild ducks, and the like. We have also tea, coffee, dried fruits, beans, a few other luxuries, and a good appetite . . . I enjoy camp life exceedingly. This living out-of-doors, night and day, I find of great benefit. I never felt better in my life. I do not know what some of your Eastern folks would say, who call night air injurious, if they could see us wake up in the morning with dew on our faces!" ·

Back in the Tenth Street Studio Building, Bierstadt worked his western sketches up into oil paintings, exhibiting them at the National Academy the following spring. They won him membership in the academy, but were not important enough to attract notice from the critics. They seemed to have eyes only for the work of Frederic Church, whose painting of a flaming sunset, "Twilight in the Wilderness" (see color insert), was attracting superlative notices at that time.

After producing a number of paintings of the Wind River Country, Bierstadt was ready to attempt a grandiose view that he hoped would compete with the best of Church's work. First, he stretched a huge canvas ten feet wide and six feet high. He used exactly the same natural elements that Church had employed in his "Heart of the Andes". central snow-capped mountains, reflecting water, and a sparkling cascade. The towering cliffs in the background reached nearly to the top of the canvas and their base was dotted with aspen, fir, and pine. The cliffs converged from either side of the painting onto a sparkling waterfall that caught the sun as if it were the beam from a spotlight cast down onto the first lady of a theatrical production.

In contrast to the luminous background, he painted the entire

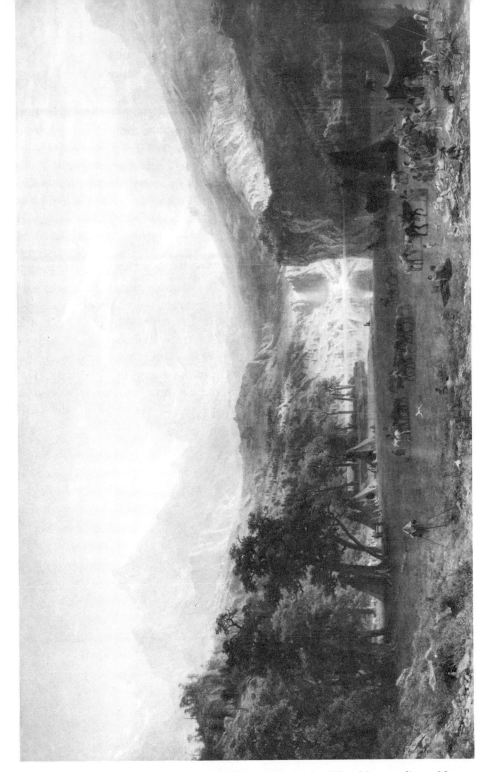

THE ROCKY MOUNTAINS by Albert Bierstadt. The Metropolitan Museum of Art, Rogers Fund, 1907.

foreground in shadow. On the lake shore he depicted a bustling Shoshone village. For this precise work he had studied the hundreds of stereographs he had taken. He depicted the braves returning to their village with carcasses of elk and mule deer flung over the rear of their ponies. Papooses were propped against the teepees, as the squaws hurried out to meet the hunters. Game lay on the grass ready for skinning. Fish was being smoked on spikes over fires. As if the Indian activities demanded a spectator, at the left, a tiny prairie dog sat attentively outside its darkened burrow, observing the preparations for the evening feast.

Bierstadt titled his painting "Rocky Mountains—Lander's Peak," complimenting his expedition leader by naming his central mountain after him. The peak, however, actually bears the name of an earlier, better-known surveyor, John Charles Frémont, who had been the Republican candidate running against James Buchanan (and losing) in the 1856 presidential election. "Rocky Mountains" would not be noticed for a number of years after Bierstadt's trip to Wyoming. The southern states had seceded from the Union, and nearly everyone was distracted by the events that led to the outbreak of the Civil War.

XV

The Civil War Begins

It looked like a low cloud of steel gray-blue floating down Broadway. As it grew closer the sounds of drums and trumpets could be heard. Whittredge and Bierstadt were standing on the corner carefully scanning the passing faces. Suddenly, they cheered and waved. Sanford Gifford turned his head and smiled proudly as he marched in the ranks of the 7th Regiment—the first volunteer troops to leave New York for Washington. Whittredge had also tried to enlist, but volunteers in those days were required to supply their own uniforms and equipment. Not able to find a knapsack, he had been turned down.

After the first shots had been fired at Fort Sumter, South Carolina, in April 1861, New Yorkers had united their efforts to preserve the Union. Volunteer regiments were hastily organized and drilled. Committees were set up to sew, knit, roll bandages, and collect funds for relief work. Whittredge was one of the few men adept enough with a needle to be allowed to join a sewing society, which concluded each meeting with a a game of charades. Bierstadt, accompanied by Leutze, who had given up his Düsseldorf studio for the con-

genial atmosphere of the Tenth Street Studio Building, made an excursion to Washington to photograph the army camps. Having returned to New York after a month's service, Gifford painted a number of oil paintings of camp scenes. Bierstadt produced one major Civil War painting, "The Bombardment of Fort Sumter," which he painted entirely from imagination. Most of the artists agreed that the army camps had more to interest the genre painter than the landscape painter.

Church did not pack his paintbox to follow his fellow artists to the battlefront. Instead, he looked for an event in nature to portray the country's violent upheaval. He studied his sketches of erupting volcanoes taken during his last trip to South America, and worked them up into a large oil painting (a seven-footer) entitled "Cotopaxi."

When it was exhibited at Goupil and Company in the spring of 1863, the critics proclaimed it another masterpiece. The New York *Times* described it as "throbbing with fire and tremulous with life." Church had shown the erupting volcano some fifty miles across a rocky plain. The black smoke shooting from the crater was bent downward by high winds, obscuring the morning sun with dust and ashes.

As viewers admired "Cotopaxi," the sound of distant drums echoed through the streets of New York. Regiments were quartered in city buildings and drilled in Central Park. To the cry of "Extra, extra!" newspaper boys announced the defeats and victories of fierce and bloody battles. Behind Church's depiction of the volcanic holocaust lay the specter of hot flashes of rifles, the wild explosions of shells, and the yellow smoke clouds of the battlefields. Once again, Church had captured through nature the exact temper of the times.

Goupil was also the scene that year for an exhibition of the wet-plate photographs of California's recently discovered Yosemite Valley taken by the photographer-explorer C. W. Watkins. These photographs showed a deep valley with enormous granite cliffs rising some four thousand feet above it. There was the Merced River winding through the valley and the gigantic mass of unbroken granite known as El Capitan. Yosemite Falls had been photographed in their entirety, leaping off a cliff, taking a non-stop plunge to a ledge, then showering the valley thousands of feet below with spray. Bierstadt

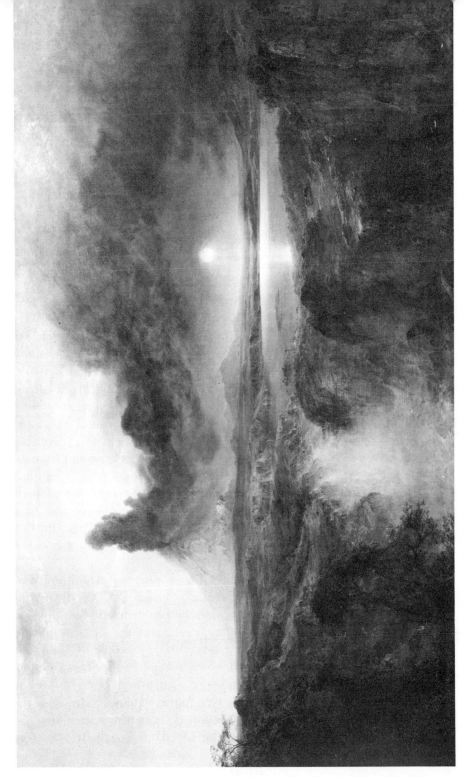

COTOPAXI by Frederic Church. On loan to the Metropolitan Museum of Art, from John Astor.

studied these photographs with great curiosity. The water must have fallen at least half a mile. It was hard to believe that nature had created such a spectacle.

When he returned to his studio, where "Rocky Mountains" hung elaborately framed and ready for exhibition, he sat down in a sling-back chair and contemplated the huge painting. Interesting, he thought, how he had painted the Wyoming peaks as though they were impassable barriers to the West, and yet, beyond them lay more dazzling falls and beautiful valleys than he had ever imagined. Could he survive the dangers of traveling over these rugged peaks, across the barren deserts and through Indian country? Hundreds of emigrants had made their way over these trails to Oregon and California. He became determined to reach the West Coast and to be the first painter to depict Yosemite—at any risk.

Bierstadt had often dined with the New York *Evening Post* art critic, Fitz Hugh Ludlow, and his beautiful wife, Rosalie. Ludlow had been one of the few critics to take notice of Bierstadt's work, singling out his paintings in the 1862 and 1863 National Academy Exhibitions for favorable comment. As a boy in Poughkeepsie, New York, Ludlow had passed his spare time nosing around the local drugstore. One day he found some hashish and began to experiment with it. By the time he entered Princeton University, he had become addicted to the drug. He wrote an account of his efforts to free himself of the addiction in a brilliant book, *The Hasheesh Eater*, which immediately became a best seller and cast Ludlow into the role of a celebrity. Looking for adventures to fill a new book, the brilliant but unstable author agreed to accompany Bierstadt on his trip across the continent.

After arriving by train in the frontier town of Atchison, Missouri, the stalwart artist and the reckless writer took the Overland Coach to Denver, Colorado. In Colorado Bierstadt and Ludlow attended a buffalo hunt, visited Pikes Peak, and the Garden of the Gods. The artist left such an impression on the people of Colorado that one of their highest mountains was named in Bierstadt's honor. From the streets of Denver today the 14,060-foot peak of Mount Bierstadt can be seen near the somewhat higher Mount Evans.

Ludlow began to write his account of the journey soon after he and Bierstadt had left Denver on the Overland Coach. It was over

380 miles to their destination, Salt Lake City. After days of lurching and swaying over winding mountain roads, Ludlow realized that the Rocky Mountains were not a single chain as most Easterners thought, but a series of mountain ranges that reached all the way from Denver to Salt Lake City. To the fanciful young writer they seemed like "a giant ocean caught by petrification at the moment of the maddest tempest."

Before they entered Salt Lake City, they passed the strange sandstone formations of Church Buttes. Erosion had molded the reddish-brown bluffs into weird shapes that reminded Ludlow of several partially connected Gothic cathedrals. He imagined some of the rocks taking the shape of niches containing grotesque statues. Others looked like flying buttresses. Bierstadt was so taken by the sight that he exclaimed, "Oh that the master-builders of the world could come here even for a single day! The result would be an entirely new style of architecture—an American school, as distinct from all the rest . . ."

Finally they arrived in Salt Lake City—populated entirely by the Mormons and ruled with an iron hand by their president, Brigham Young. They were amazed to discover an opera house that seated twenty-five hundred people, and gardens teeming with apples, apricots, gooseberries, and plums. They attended a Fourth of July Ball, but were scolded by Young for arriving late. It had begun at four o'clock in the afternoon. They talked with Young about the Civil War. "When your country has become a desolation," he announced, "we will forget all your sins against us, and give you a name." Brigham Young believed that the Civil War would create such chaos in the east that the survivors would be forced to find refuge with the Mormons in Utah. With New York City in the midst of its bloody Draft Riots at that time—where over one thousand people were killed or wounded—Young's argument might have seemed credible.

Swimming in the Great Salt Lake was a delightful experience. The density of the salt in the water buoyed them up so much they did not sink below their armpits. "I swam out into it for a considerable distance," Ludlow reported, "then lay upon my back *on*, rather than *in*, the water, and suffered the breeze to waft me landward again. I was blown to a spot where the lake was only four inches

deep, without grazing my back, and did not know I had got within my depth again until I depressed my hand a trifle and touched the bottom." A painting by Bierstadt survives that shows the two of them floating in the briny Great Salt Lake.

Soon after the Fourth of July, Ludlow and Bierstadt left Salt Lake City and began their journey west over four hundred miles to Virginia City, Nevada. The road lay through the most forbidding desert. The sand was a powder of alkali, white as snow. It stretched for ninety miles in one uninterrupted sheet. There was no vegetation, and the water was so bad that travelers described it as hell-broth. For six days and nights the stagecoach jolted through the deep, powdery sand. Sleep was impossible.

On the second day out from Salt Lake they stopped at a station where they learned that the Goshoots were on the warpath. By noon they had spotted moccasin tracks in the dust and a Goshoot scout on a distant ledge. There was no chance of outrunning the Indians. The horses could hardly drag the coach, which was sunk up to its hubs in sand. There were ten rifles in their party. They ran them out of the coach windows, five on each side. Their six-shooters lay across their laps, their bowie knives were at their sides, and their cartridge boxes swung open on their breast straps. They sat with tightly clenched teeth—only muttering now and then to each other, in a glum undertone, "Don't get nervous—don't throw a single shot away—take aim —remember it's for home!" Sometimes a silent squeeze of the hand was all that passed, as they sat with one eye glued to the ledges and their guns poised for attack.

The passengers hoped to intimidate the Indians with the military appearance of the stagecoach until they reached an overland station. At last, the site came into view, but all they saw there was thick smoke curling up into the sky. The barn, stables, and station house were a smoldering pile of rafters. A dozen horses lay roasting on the embers. Six men with their brains dashed out, their faces mutilated beyond recognition, and their limbs hewn off, were sprawled out with the carcasses of beasts. It was a frightful sight steaming up into their faces. After that, they toiled on with their nearly dying horses. After a hundred miles more of tortured suspense, they arrived in Ruby Valley, Nevada, at the foot of the Humboldt Mountains, and left the last Goshoot behind them.

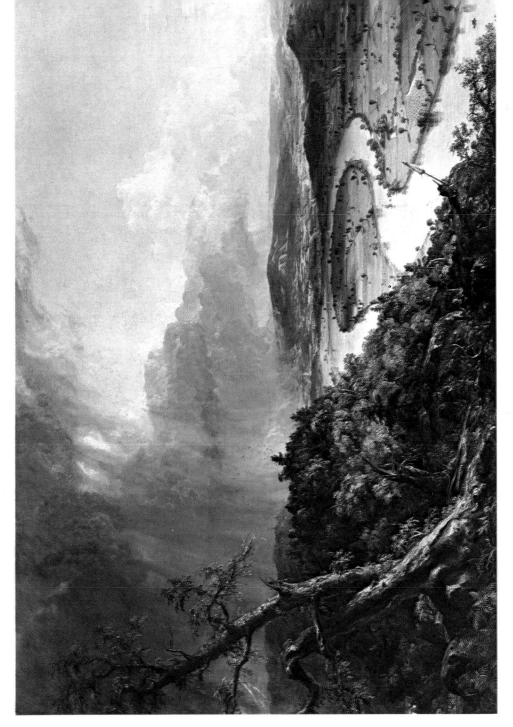

THE OXBOW (THE CONNECTICUT RIVER NEAR NORTHAMPTON)
by Thomas Cole. The Metropolitan Museum of Art. Gift of Mrs. Russell Sage, 1908.

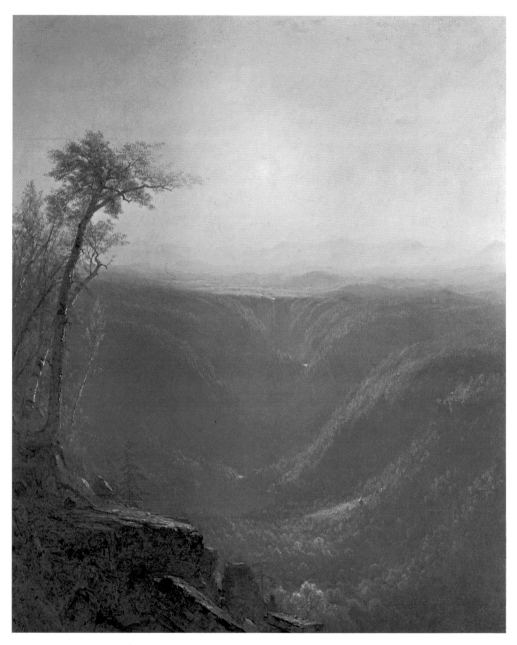

KAUTERSKILL FALLS by Sanford Robinson Gifford. The Metropolitan Museum of Art, Bequest of Maria De Witt Jesup, 1915.

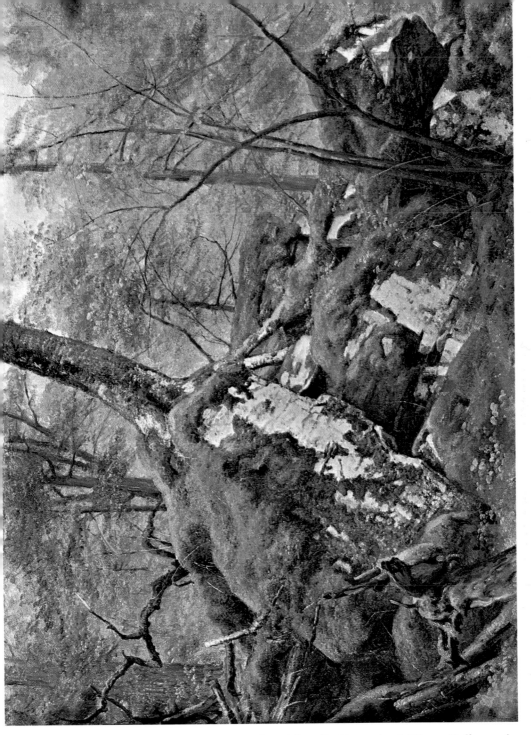

STUDY OF WOOD INTERIOR by Asher B. Durand. Addison Gallery of American Art, Phillips Academy, Andover, Massachusetts.

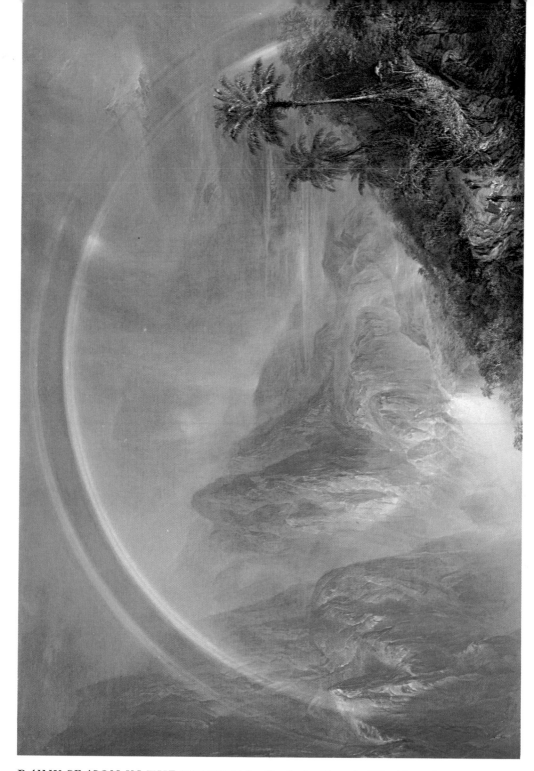

RAINY SEASON IN THE TROPICS by Frederic Church. The Fine Arts Museums of San Francisco, California Palace of the Legion of Honor, Museum purchase, H. K. S. Williams Fund for the Mildred Anna Williams Collection.

They still had to cross what is today the state of Nevada before reaching the silver mining town of Virginia City, situated near the California border. When they finally arrived, their very marrow was almost burned out by sleeplessness, sickness, and mental agony. The morning before, a stout, young Illinois farmer, whom they had regarded as the staunchest of all their fellow-passengers, became delirious, and had to be held in the stagecoach by force. When they were changing horses near Carson Sink, another traveler became suddenly insane, and blew his brains out. The moment he entered a warm bath in Virginia City, Ludlow fainted. We are not told how Bierstadt fared, but he had to possess an iron constitution to have survived the journey. Ludlow was later to exclaim, "I look back on the desert as the most frightful nightmare of my existence."

Once recovered from their desert ordeal, the two men took a stagecoach over the Sierra Nevadas and down to the beautiful San Francisco Bay. A first visit to San Francisco, Ludlow reported, ". . . has the interest of a new planet. It ignores the meteorological laws which govern the rest of the world. There is no snow there. There are no summer showers . . . The thin woolen suit made in April is comfortably worn until April again." They found the elegance, service, and food of the Occidental Hotel better than any they had known in New York. For two weeks they enjoyed old friends, casinos, and fresh strawberries for breakfast every morning.

But the enjoyment of these luxuries was to last only until they could complete preparations for their anticipated trip to Yosemite Valley. The party consisted of two other artists, two scientists, a few friends, a camp cook, and an Indian boy. For the first part of their journey, the road was wide enough to carry their supplies by wagon. When the trail narrowed, they roped their supplies to the backs of pack mules and climbed and descended the mountains in single file.

After days of traveling, they suddenly emerged from the thick foliage to find their horses standing on the verge of a precipice more than three thousand feet in height. Facing them stood another wall, but how far off it was they could only guess. The distance was so great that it baffled any effort to calculate it. Their eyes were caught by a tremendous dome which stood smiling, Ludlow imagined, "in all the serene radiance of a snow-white granite Buddha . . ." Not a living creature, either man or beast, broke the silence of the paradise.

The only sign of motion came from the Merced River which appeared like a shining serpent threading the middle of the grass. Before them lay the glorious Yosemite Valley. They were so taken by the sight that they felt they looked not so much on "a new scene on the old familiar globe as a new earth into which the creative spirit had just been breathed."

After taking all this splendor in, they wound their way down the face of the precipice and by twilight had reached the meadows on the banks of the Merced River. There they made their camp. They unsaddled the horses, put them out to graze, and gathered dead wood for the fire. A nearby brook furnished the hungry men with enough frogs for an unexpectedly delicious main course. After dinner they smoked their pipes around the fire, then pushed together some evergreen strewings and slept soundly on these soft, fragrant mattresses.

For seven weeks the little group of explorers remained in the valley. Rising at dawn each morning, they enjoyed a hearty breakfast of flapjacks and coffee. Then each man followed his own pursuits: the artists rode off with paintboxes and camp stools, the naturalists with their botany boxes and bugholders, and the gentlemen of leisure with fishing rod and gun. The artists often worked so hard that they did not return to camp for lunch. At noon the Indian boy would carry out to them in a pail a bit of grouse, quail, or pigeon fricassee with dumplings. The boy and his pony were so thin that the artists nicknamed them "Death on the Pail-Horse." In the evening, the artists exhibited their works, and the naturalists showed an unusual butterfly or insect. Occasionally Bierstadt, who could catch as many as twenty trout in a few minutes by tickling them on their stomachs, would provide the entire camp with a special treat for dinner.

The artists thought of the beautiful valley as a divine workshop. Each day, a little after sunrise, Ludlow told how they "began labor in that only method which can ever make a true painter or a living landscape, *color*-studies on the spot." He summed up their experience in the valley as follows: "They learned more and gained greater material for future triumphs than they had gotten in all their lives before at the feet of the greatest masters."

The autumn was coming. Most of the group returned to San Francisco. Bierstadt was eager to make sketches of the famed moun-

tain peaks of the northwest. Bidding farewell to the others who had become sated with travel, he and Ludlow, unaccompanied, continued on horseback to northern California, Oregon, and Washington. Having sent their luggage ahead by California Express, they could ride forty miles a day. Western horses, they noted, could lope all day long. They loved the comfort of the western saddle, never tiring in it as they would in the "slippery little pad" that Easterners used. But the long, fast rides through boundless plains of wild grass and thick groves of California oak lasted only as far as the termination point of the California Express. Here they picked up Bierstadt's heavy paintbox. They struggled, alternately, to carry it on the pommels of their saddles, until at last they persuaded a wagoner to carry it for a trade of cheap watches. Freed of the burden, they allowed their horses the first gallop of the day.

Staying mostly at ranches through northern California, Bierstadt and Ludlow sometimes found good accommodations, sometimes bad ones. At one rancher's they had to eat a dinner of hen-stew that was one third feathers and sleep in a room with flea-bitten children who were sick with colds. Near Mount Shasta they found the attractive Sisson family living in a two-story house that ran in all directions. Mr. Sisson, who had given up schoolteaching in Illinois, was an excellent woodsman and the best rifle shot they had ever seen. Since Mrs. Sisson was a first-class cook, they dined on roast venison, potatoes in cream sauce, and pears baked in syrup. What a treat for men who for weeks had eaten only pork and biscuits!

No mountain that Ludlow and Bierstadt had ever seen compared with the 14,162-foot Mount Shasta. "When we first saw the whole of it distinctly," Ludlow wrote, "it seemed to make no compromise with surrounding plains or ridges, but rose in naked majesty, alone and simple, from the grass of our valley to its own topmost iridescent ice." When they departed, they were loaded with a paintbox full of Shasta studies taken from every possible position, and at every time of day; an abundance of venison, and a journal full of vivid descriptions.

By November Bierstadt had sketched the shapes and outlines of Oregon's 11,245-foot Mount Hood and Washington's 14,410-foot Mount Rainier. The two travelers were now ready to return to New York. Rather than take the risky trip across the continent again, they

booked passage on a steamship from Portland to San Francisco, and then south to the Isthmus of Panama. They crossed the Isthmus, caught another steamship north to New York, and arrived there just in time to spend Christmas at home.

XVI

Art Peaks
During Civil War Years

Great fortunes were lost and gained during the Civil War. Many merchants with business connections in the South went bankrupt, as those who owned woolen mills, shoe factories, munitions plants, and steel foundries made huge profits. Inflation was rampant, but New York City on the whole prospered as never before. Its cultural life was booming; the wealthy came out in full force to attend special concerts, lectures, theatre benefits, art exhibitions—all arranged to raise money for war relief. Tickets for artists' receptions were especially difficult to find because, as Whittredge explained, "so many fine people were desirous of attending them." Charitable causes became a patriotic excuse for an array of social events.

One of the most important volunteer organizations was called The Sanitary Commission. It was created to improve conditions in the Union army camps and to provide better care for the wounded—a type of work later handled by the Red Cross. In the winter of 1864, it was preparing for the most extravagant fund-raising event of the war years. Hundreds of committees were meeting in homes all over the city making plans for its huge Metropolitan Fair.

Nearly every trade, profession, literary and artistic society participated in the event. Auxiliary committees were set up in London, Paris, and Rome. Two new buildings were constructed to hold the exhibitions. The Fourteenth Street building contained oval stalls where all kinds of donated items were on sale—the finest being an unpublished manuscript of James Fenimore Cooper, and the original bowie knife made for James Bowie, who fought at the Alamo. The temporary building on Union Square was decorated by Richard Morris Hunt with bright banners, spring flowers, and bubbling fountains. One of the most popular areas was the Colonial Kitchen, where people could savor an old-fashioned meal.

For days before the opening, the fair buildings bustled with activity as men in frock coats and women in hoop skirts received and unpacked parcels sent from all over the world, and distributed them to the correct booth. Eleven thousand soldiers turned out to march in the opening-day parade, carrying tattered flags ripped by Confederate bullets. Milling crowds packed the exhibition halls. Saleswomen were identified by white collars and blue ribbons pinned diagonally to their shawls. Entertainment ranged from plays performed by prominent members of society to Indian war dances around a teepee lent by Bierstadt. The fire department was alert to any signs of fire. The police looked out for pickpockets. They caught a number of them, and before taking them to jail, marched them up and down the aisles with a card around their necks reading PICKPOCKET. The fair was such a success that it closed after three weeks with proceeds of over one million dollars.

The exhibition galleries of the fair held over six hundred works of art. Some of these had been donated for sale by the artists. Others had been carefully chosen by the Art Committee Chairman, John Kensett, for their popular appeal. Paintings from the Düsseldorf School and French Academy took nearly half the space. The rest was devoted to the works of American artists. Leutze's popular "George Washington Crossing the Delaware" hung at one end of the room. Church's celebrated "Heart of the Andes" was on display once again, but the crowds were rallying around another painting directly opposite it, entitled "Rocky Mountains—Lander's Peak." Bierstadt had waited for this important occasion to present his huge masterpiece to the widest public possible. It was an immediate hit. Newspapers and

magazines were filled with reviews of the new painting. One art critic wrote, "There are certain passages of it which indicate an acquaintance with artistic means unsurpassed in any painting of our age and country . . . the handling of these particulars is of a perfection which would entitle Bierstadt to the name of a great workman, did he not deserve that of a great artist more justly still." Critics agreed that "Rocky Mountains" placed Bierstadt "in the first rank of American genius." It attracted such wide attention that he became famous overnight, and Church, four years his senior, found himself with a rival.

At the same time that Bierstadt joined the leadership of the Hudson River School, a number of other talented painters were emerging. Jasper Cropsey, also exhibiting at the Metropolitan Fair, had won fame some years earlier in London by exhibiting in his studio a large-scale painting entitled "Autumn on the Hudson River" (see color insert). In this daring work he had portrayed the maples, elms, and birch trees in blazing scarlets and yellows. With such seasonal splendor unknown in England, the critics accused Cropsey of exaggerating nature's colors. In response to their disbelief, Cropsey sent home for some red and yellow maple leaves, which he pinned to a board near his painting. The critics now had to admit that the brilliance of autumn in the northeastern United States had been entirely new to them. The controversy brought the press rushing to the exhibition and Cropsey managed to collect as many as fourteen reviews of his work.

After seven years in England, Cropsey sailed into New York Harbor on July 4, 1863—a terrifying moment to arrive in this wartorn country. The North had just won the battle of Gettysburg, but a few days later violent mobs raged through New York streets, burning, killing, and destroying in protest against the draft laws. Cropsey's purpose in returning during the most violent battles of the war was to use these historical sites as subjects of his paintings. He went almost immediately to Gettysburg—completing a large painting of the battlefields sometime later. Cropsey's desire to find historical implication in landscape harks back to Thomas Cole—whose influence appears in much of Cropsey's early work. Only Cole had previously dared to clothe his wilderness scenes in autumn colors—as in his well-known "Schroon Mountain." Far more daring than Cole in his use of color, Cropsey took on this brilliant season as the theme of his life

work. The American critics responded enthusiastically by interpreting his fiery celebration of autumn scenery as further evidence of God's blessing on this soil, and Cropsey's work became a popular facet of the Hudson River School.

During the 1860s, Whittredge sought out as subject for his paintings the dark, damp recesses of the Catskills. It was a crucial time in his career as he struggled to throw off the memory of the orderly forests that he had painted for a decade abroad. In European forests the peasants collected the fallen sticks to burn as firewood, but the American forests remained a tangled mass of decaying logs and thick underbrush. At the National Academy Exhibition of 1864, however, Whittredge proved that he could compete with the best of the Hudson River School in his painting "The Old Hunting Grounds" (see color insert). The overhead foliage is so dense that only a few flecks of blue sky penetrate it. A deer takes a drink from a stagnant pool. On its banks a deserted canoe lies broken and rotting —a reminder of the days when these forests were the hunting grounds of Indians. The branches of the tall trees bend like the vaulted arch of a cathedral—suggesting that the true place of worship was not in the congregation of a church, but in the silence of the great woods.

Martin J. Heade also found his mature style during the Civil War years. He had been born in Lumberville, Pennsylvania, the son of a prosperous farmer and lumber dealer. He studied coach painting for a time with the well-known primitive painter and Quaker preacher Edward Hicks, who lived fifteen miles away; and later, with Edward's nephew, Thomas Hicks. When he arrived at the Tenth Street Studio Building, he was already forty years old, having spent his life roaming this country and Europe, painting second-rate portraits, genre, and still-lifes. Church's success with "The Heart of the Andes" persuaded him to take up landscape. He followed the path of the Hudson River artists to the White Mountains and Lake George, but the kind of scenery that inspired his talent was not the mountainous regions, but the low, flat salt marshes near Newburyport, Massachusetts. In 1863, he produced a large number of serene, glowing, coastal and marsh scenes in a very distinct and personal style. The burst of activity produced enough money for a trip to Brazil, where he painted tropical landscapes and glistening little paintings of his

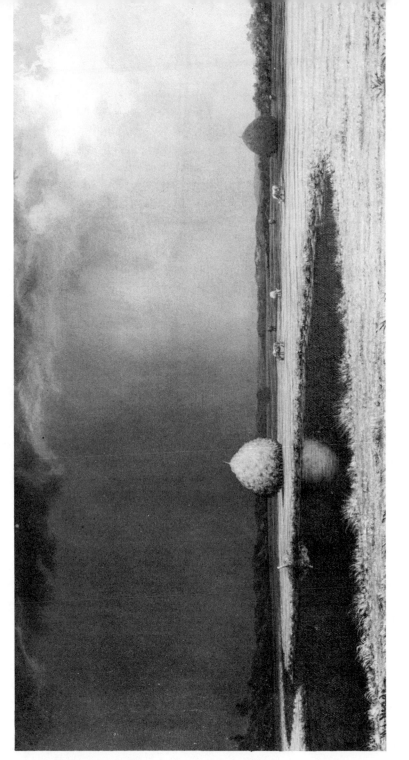

SALT MARSH HAY by *Martin J. Heade. The Butler Institute of American Art, Youngstown, Ohio.*

special pets—the hummingbirds—a subject, like that of the salt marshes, which consumed his interest for years to come.

Although Heade's rich personal style appears highly exciting today, in his own time his work was hardly noticed. He was the only skilled landscape painter in New York who did not become a member of the National Academy, although he exhibited there frequently. He was refused membership at the Century Club, of which the leading artists of the Hudson River School were all active members. His paintings sold for sixty dollars when those of his colleagues were bringing much higher prices. His style may not have been true enough to nature to have popular appeal in his time, but Heade may also have added to his failures by carrying a chip on his shoulder. His photograph reveals a hard, unpleasant-looking man with an egg-shaped head framed in tight blond curls and frizzy sideburns that taper off at the chin. There is arrogance in his cold, oblong eyes. He felt uncomfortable among the socially elite, once announcing that he would never "be placed in the ranks of the 'boot lickers' to the rich." And yet, he did strike up a lifelong friendship—sometimes one-sided—with Frederic Church, who was both wealthy and celebrated.

After two years at the Tenth Street Studio Building, Heade left for Boston, but he returned occasionally to borrow Church's studio when he was absent. Heade's canvases could often be found stashed away in Church's studio. A story is told that one day Church picked up one of Heade's unfinished paintings of a marsh scene. The lower portion of the canvas had been left blank. Mischief-loving Church could not resist filling it in. First, he painted two sawhorses that appear to support the marshland; then he painted dribbles of water to give the effect of the marsh leaking. In the center he painted a dancing, grinning gremlin.

Many of Heade's landscapes, such as "Salt Marsh Hay," reveal a deep concern with the quality of light. Kensett's and Gifford's work also emit a new, luminous effect. Art historians consider these paintings to be examples of a trend that arose in the 1860s called luminism. Luminist landscapes are often bathed in a shadowless, glaring atmosphere that gives them a unique character. Heade's light was often quiet and eerie; Kensett's soft and gray; and Gifford's thick and rosy. They reduced nature to simple forms, often balancing bands

of a serene sea or marsh with a well-placed rock, sailboat, or haystack. They did not break the light up into dots, as the French Impressionists, but maintained smooth brushwork and a polished surface.

Gifford returned home after a few months on the front to paint one of his finest works in the luminist style, entitled "Kauterskill Falls" (see color insert). Although his subject had been painted by nearly every Hudson River School artist, Gifford interpreted it in a manner which was entirely original. His aim was not to catch each leaf, twig, and branch that Durand had attempted in his "Kindred Spirits," but to paint the rosy haze that lay between the golden birch in the foreground and the barely visible falls in the distance. Critics, who had not examined the subtle gradations of sunlit air, accused Gifford of painting as if he were looking through colored glass. But Gifford understood his goals and described his work as "air painting."

Although he had been painting in his mature style for many years, Kensett's work also moved at this time toward greater expression of light for its own sake. Being a natural organizer, Kensett had devoted a large portion of his time to charitable causes during the war years, and his output slowed down. In 1864, however, the Century Club showed their respect for his talent by offering him a commission at one of the highest prices his paintings ever brought—five thousand dollars.

The first evidence of a spectacularly rising art market occurred just before the war broke out, when a New York manufacturer, William T. Blodgett, bought Church's "Heart of the Andes" for the astounding price of ten thousand dollars. Just as fortunes were changing hands during the war years, so were art collections being actively bought and sold. Auction galleries were packed, and fabulous prices were being obtained. In 1862, the Düsseldorf Gallery finally folded and its painting collection sold for an amazing figure of forty-five thousand dollars. But what appears to have made the greatest impact on the market was the London sale of a collection of paintings owned by an ordinary middle-class merchant, Elhanan Bicknell. By buying straight from the artists at low prices, he had built an important collection of contemporary paintings including a number of works by Turner. When his collection was sold in London it brought the surprising figure of three hundred thousand dollars . . . an

extraordinary rise in the market value in one man's lifetime. After the sale of the Bicknell Collection it became apparent to many that buying art was not just a "worthy cause," but an investment which could increase considerably in value. Prices rose, and in 1865, James McHenry, an American living in London, purchased Bierstadt's "Rocky Mountains" for twenty-five thousand dollars—the highest price ever paid for an American painting.

The National Academy also benefited from the rising interest in art. From time to time in their vagabond history, the members had made attempts to purchase a permanent home, but none of these had succeeded. Once again the subject had arisen, a plot of land had been purchased, and designs were being submitted. The artists began to quibble over the architecture. It looked as though reaching an agreement on the designs was going to be a long, trying task. The outbreak of the war, however, brought a halt to the planning. Durand, worn out at sixty-five years of age, decided to resign after serving sixteen years as president. The academy appeared unprepared for his departure, finding it necessary to summon the seventy-year-old former president, Samuel F. B. Morse, to serve again. Once a young, rebellious organization, the academy was now controlled by a group of aging artists. A year later, however, they recovered some youth in the election of the forty-six-year-old portrait painter Daniel Huntington, who decided to proceed with the building despite the condition of the country.

Before construction could begin, the council had to agree on whether they wanted to erect a plain brick building, or whether they should risk trying to raise enough money to build an example of the finest taste of the times. For three years the academy remained in a deadlock over this issue. Finally, a member of the council proposed starting a Fellowship Fund composed of one-thousand-dollar memberships. John Kensett, a bachelor who had a reputation of appearing nightly at the finest dinner tables in the city, became one of the prime fund raisers. He and his committee pursued the rich from their Wall Street offices to their Fifth Avenue drawing rooms so persistently that by May 1863 they had met their goal of one hundred thousand dollars.

By the following October, a ceremony was organized for the lowering of the cornerstone. Members of the academy and guests as-

sembled at the Century Club at East Fifteenth Street, and marched from there, in their silk hats and black coats, to the academy plot on Twenty-third Street and Fourth Avenue. The procession was led by the janitor, who carried the copper box to be placed in the cornerstone. The speeches began with an invocation given by Rev. Francis Vinton, who asserted that the building was devoted to the honor of God, the benefit of his creatures, and to the beautiful in nature. "Nature is the art of God," he said. "Thou, Lord, hast made all things beautiful." The white-whiskered William Cullen Bryant recollected in his speech events that led to the birth of the National Academy forty years earlier. "I lent its founders such an aid as a daily press could give," he told the audience, "and its pupils accepted from me a short course of lectures on the Mythology of the Ancients." In those days he could count "the eminent artists of the country on his fingers." Today, who could enumerate all the men who had "devoted their genius to the Fine Arts"? Between each speech the band played, and at last the architect Peter B. Wight presented President Huntington with the silver trowel to lay the cornerstone.

In the spring of 1865 the new National Academy building was opened to the public. It was a highly ornamented building resembling the Doge's Palace on St. Mark's Square in Venice so much that it was often referred to by that name. Venetian Gothic had been the favorite style of John Ruskin, who admired its extensive use of forms from nature. The landscape artists who dominated the academy were proud that the carved decoration on the building was taken from flowers, vines, and leaves rather than from human forms. Pointed arched windows ran around the first story of the large rectangular building with the upper walls pierced only by small round windows filled with tracery. Gray and white marble blocks arranged in stripes, checks, and zigzag patterns decorated the entire surface, and a delicately carved cornice crowned the top.

Beneath the landing of the staircase that led the visitor to the entrance there was an arcade that enclosed a drinking fountain for any thirsty passerby. Inside, a ticket office and umbrella stand stood on either side of the mosaic-floored vestibule. The Great Hall was dominated by a double staircase that led to the upper galleries where the exhibitions were held. Who would have guessed that after decades of

renting halls here and there the foremost promoter of American art would, at last, settle into a Venetian palace!

It was a grand opening indeed, with ladies and gentlemen in full dress, concert music, and paintings that celebrated the scenic regions of the country from the Atlantic to the Pacific Ocean. Celebration was in the air that spring. On April 10, New Yorkers received news that Lee had surrendered. Four years of the most bloody war in the history of the country had come to an end.

XVII

Post-war Exuberance

One prominent member of the National Academy was noticeably absent from the festivities that spring. Frederic Church had made a hasty departure to Jamaica. In March his three-year-old son and one-year-old daughter died of diphtheria within eight days of each other. Heartbroken, he painted two small paintings as memorials to his dead children: a moonrise and a sunrise. Then, he and Isabella packed up their trunks and sailed to the West Indies.

For five months Church traveled about the tropical island sketching with the fervor of a man trying to relieve his mind of a painful memory. He also knew that he no longer stood alone as foremost landscape painter. Since the Metropolitan Fair the press, when writing of American landscape, was now referring to "Church and Bierstadt."

Revived by his trip, Church arrived home to compose one of the most cheerful masterpieces of his career, "Rainy Season in the Tropics" (see color insert). It was a painting of a misty landscape bathed in golden light with a perfectly arched rainbow reaching

from a tropical hillside to the glowing cliffs. The world was hopeful again—Church's homeland was at peace and his wife was expecting another baby.

At this time Bierstadt was enjoying his most productive years, working on large paintings of Yosemite Valley and other scenic regions that he had sketched on his trip across the continent. A Colorado scene, "Storm in the Rocky Mountains," was first shown at a benefit for the Nursery and Children's Hospital in February 1866. The painting's central mountain soared so high in the clouds that one critic estimated that if the proportions were correct it would have to be 10,000 miles high. The fantastic height revealed Bierstadt's elation at the time. He named this lofty peak Mount Rosalie. He had fallen in love with the beautiful, brown-eyed Rosalie Osborne Ludlow, who had divorced Fitz Hugh Ludlow, and on November 21, 1866, married Albert Bierstadt.

Ludlow, who had never been a good husband, was thoroughly displeased with the marriage. In his book about their trip to the West Coast, *The Heart of the Continent,* he did not make one mention of the man whom he had formerly described as his best friend. Ludlow had become increasingly unstable. He had returned to hashish and began, also, to drink heavily. His friends lost all patience with him and his health began to deteriorate. He went to Switzerland in hopes of finding a cure, but died there only four years after his divorce.

From his bachelor days, Bierstadt had been a popular member of New York's social circles. He possessed charm, warmth, and a wealth of adventure stories that delighted his dinner partners. His good looks, distinguished bearing, and polished manners made him completely acceptable to the rich and titled, whom he cultivated with great success. He combed his brown hair to the side, and wore such a bushy walrus mustache that his mouth was completely hidden beneath it. He had frank, confiding eyes. He was so attractive to the ladies that one New York matron peppered her diary with frequent exclamations that Mr. Bierstadt, the artist, was the most charming man attending the New York balls.

As Fitz Hugh Ludlow's wife, Rosalie had moved among the most cultivated people of New York. She was admired for her beauty, outspokenness, and wit. She and Albert took easily to the social whirl, making a perfectly suited couple who loved to attend elab-

orate dinners, masquerades, and balls. The thirty-six-year-old groom was so ecstatic over his marriage, he wrote to a friend, "My only regret is that I did not know my wife when I was thirteen years old, and could have married her then. I am the happiest man living."

The high prices that Bierstadt's paintings continued to command brought him a small fortune which was quickly consumed by an elaborate project begun soon after his wedding. He and Rosalie had decided to build a mansion in the most ornate Victorian style, on a hillside overlooking the Hudson River in Irvington, New York. It was situated just above Washington Irving's famous house, Sunnyside. The Bierstadts' thirty-five-room mansion was crowned with towers, adorned with balconies, and surrounded by verandas. A three-story-high studio with a floor-to-ceiling window occupied the main portion of the house, and provided ample space for the artist's large-scale paintings. Indian costumes, war implements, buffalo, moose, and deer trophies decorated the walls. From the hundreds of sketches displayed (even in the bathrooms) clients could choose any mountain, lake, waterfall, grove of trees, and wild animal they liked, and Bierstadt would combine them into a large oil painting, tagged with the name of a specific geographical location. A balcony just off the master bed-room overlooked the studio so the artist could slip out at any time to examine a work on the easel. The ground floor contained a billiard room, dining room, butler's pantry, and kitchen. Outside there were stables, a carriage house, ice house, gardens and a lawn that led down toward the river. Bierstadt's student days must have brought on happy memories, as he named this imposing structure after the Düsseldorf artist's club, Malkastan.

The spacious studio at Malkastan was perfectly fitted for the largest of all the works Bierstadt had been commissioned to paint—the nine-by-fifteen-foot "Domes of Yosemite." It was to be hung in the front hall of the Norwalk, Connecticut, mansion of the stock-broker and railroad vice-president, Legrand Lockwood. Exhibiting as much boldness in his art as he had in his travels, Bierstadt attempted to depict a view of the length of the immense valley with the shining Merced River winding through and eventually disappearing between the distant rocky walls. When it was exhibited in 1867, many critics were offended by its size. "Mr. Bierstadt," wrote one critic, "seems to be under the delusion that the bigger the picture is, the finer it is."

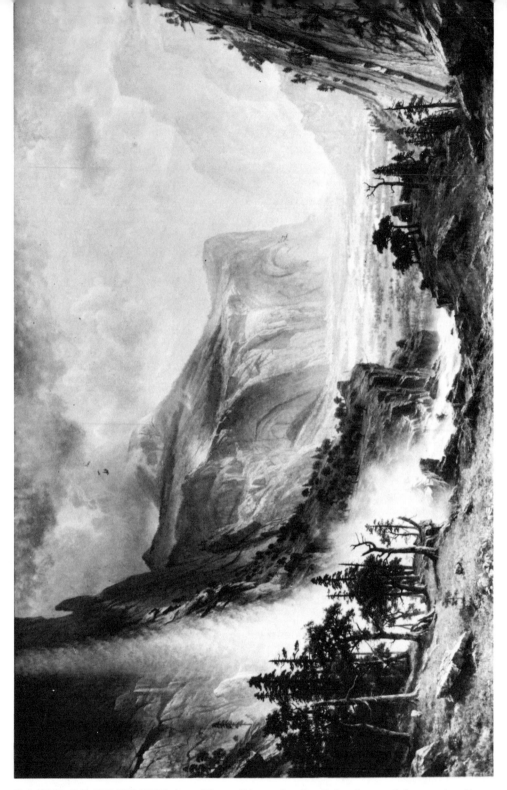

DOMES OF YOSEMITE by Albert Bierstadt. St. Johnsbury Athenaeum, St. Johnsbury, Vermont.

But other critics understood that, regardless of size, Bierstadt was a master at creating the illusion of space: "The idea of space or distance, from the foreground to the extreme point where the rocks blend with the vapoury films, is the first one that strikes the mind of the spectator. In rendering the illusion here, the artist has, we think, achieved his greatest success."

Many eastern critics, who had never seen the West, thought that Bierstadt exaggerated the proportions of the scenery. Actually, western space is immense in comparison to that of the East. Kaaterskill Falls was a mere dribble in comparison to Yosemite Falls. Bierstadt tried to tell easterners about the difference in scale in his letter to *The Crayon* of 1859: "We see many spots in the scenery that remind us of our New Hampshire and Catskill hills," he wrote, "but when we look up and measure the mighty perpendicular cliffs that rise hundreds of feet aloft—we realize that we are among a different class of mountains . . ." What we admire about Bierstadt's work today is his ability to convey the sheer size of the western landscape. His specialty was making vast spaces *look vast* on canvas.

In 1866, Whittredge made his first trip West with General John Pope, who at the conclusion of the war, led explorations to the Southwest. He rode over two thousand miles on horseback that summer, usually traveling between daybreak and one o'clock in the afternoon, at which time he would pull his sketchbox from under the piles of camp furniture heaped in the wagons and sketch until sundown. "Crossing the Ford-Platte River, Colorado" is one of the works which resulted from these sketches. He carried a revolver on these daily excursions, for the Ute Indians were on the warpath. Sometimes the artist grew annoyed when General Pope, upon seeing his white umbrella perched on a hillock in an innocent-looking landscape, would order him back to camp for safety.

In Santa Fe, Whittredge had shared the same barracks with the famous frontiersman Kit Carson, who was nearly as intrigued with Whittredge's sketching apparatus as he was by his own revolver—which, Whittredge observed, he examined nightly before placing it under his pillow. "I was the subject of the most profound interest to him," Whittredge wrote. "He said nothing about it, but I could see I was an enigma to him which he was all the time trying to solve. He looked at my sketching apparatus and then at my pictures, until finally one day he asked if he might not go with me a little way up

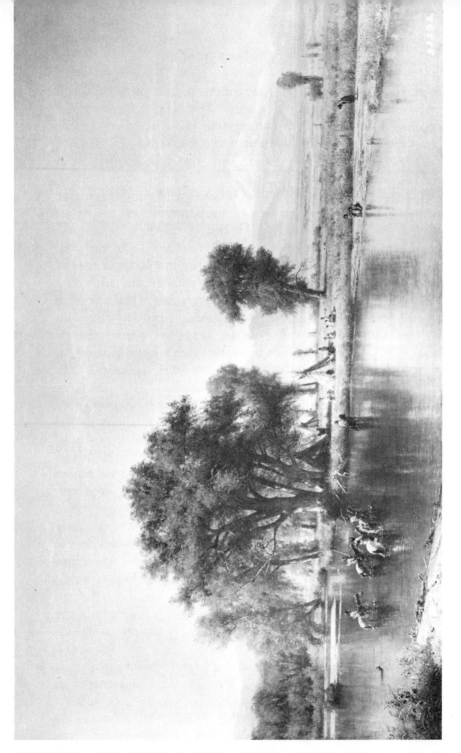

CROSSING THE FORD-PLATTE RIVER, COLORADO by Worthington Whittredge. Courtesy, Frick Art Reference Library. The Century Association Collection, New York City.

the mountain side where I expected to make a sketch." Whittredge was glad to have his company, and reported, "He stood over my shoulder a long time in silence; when finally he seemed very uneasy and asked if I would not stop painting and go a short distance and sit down on a stone with him; he had something he wanted to tell me. I went with him. He began by describing a sunrise he had once seen high up in the Sangre de Cristo mountains. He told how the sun rose behind their dark tops and how it began little by little to gild the snow on their heads and finally how the full blaze of light came upon them and the mists began to rise from out the deep canyons, and he wanted to know if I couldn't paint it for him." Whether or not Whittredge complied with Carson's request he does not tell us, but he concluded, "Nature had made a deep impression on this man's mind, and I could not but think of him standing alone on the top of a great mountain far away from all human contact, worshipping in his way a grand effect of nature until it entered into his soul and made him a silent but thoughtful human being."

On his return home Whittredge began to see a young lady whom he had known for a long time. Her father, Judge Samuel A. Foot, had been a member of the Supreme Court of New York State, and they lived in a large neoclassical house with an impressive portico. On October 16, 1867, the forty-seven-year-old artist married Harriet Euphemia Foot at Geneva, New York. Some years later Whittredge painted a view of the Foot house with a horse and carriage waiting in the driveway, his father-in-law reading on the front porch, and his daughters, Euphemia and Olive, playing in the sunshine.

In 1867, the Paris Universal Exposition offered the Hudson River artists their first opportunity to be judged as a group by a European audience. Fear that their work would not hold up among European artists had been discarded long ago. As preparations were being made, an air of confidence and good spirits pervaded the Tenth Street Studio Building. From his farm in Hudson, New York, Church wrote to Bierstadt in the city asking if he would be willing to lend him his large easel. He was coming down to put some finishing touches on "Niagara" in preparation for its journey to the exposition. Church also asked for Bierstadt's criticism: "Brush up on your intellect and be ready to find all the fault you can," he wrote. Bierstadt's

"Rocky Mountains" would also be sent to the exposition, leaving a large bare wall in the McHenry's great house, Oak Lodge, in the heart of London. Gifford's "Twilight on Hunter Mountain," Whittredge's "Old Hunting Grounds," Kensett's "Autumn Afternoon on Lake George," and Cropsey's "Mount Jefferson, New Hampshire," were presented to European viewers. Both "Niagara" and "Rocky Mountains" won awards. It was apparent that Americans had succeeded in creating a unique national style. One foreign critic wrote: "Every nation thinks that it can paint landscape better than its neighbor; but it is not every nation that goes about the task in a way peculiar to itself. No one is likely to mistake an American landscape for the landscape of any other country. It bears its nationality on its face smilingly."

Kensett, Church, and Bierstadt sailed off to Europe to see the exposition. Kensett returned shortly, but Bierstadt and Church remained out of the country for two years. The Bierstadts traveled throughout Europe enjoying the hospitality of earls, dukes, counts, and barons. They were introduced to Queen Victoria and attended a private concert played by the Hungarian composer Franz Liszt. Bierstadt hosted a lavish dinner at the Langham Hotel in London for Henry Wadsworth Longfellow, who was receiving an honorary degree from Cambridge. All sorts of notables attended, including the poet Robert Browning, the artist Edwin Landseer, and the Prime Minister, William Gladstone. Cyrus Field, who had laid the first successful transatlantic telegraph cable just two years earlier, was also present. They enjoyed a dinner of fish, game, veal, chicken, artichokes, and corn, and a George IV pudding for dessert. After the men finished this savory dinner, the ladies were presented and music began.

As the Bierstadts were enjoying the high life among the nobility and elite of Europe, the Churches were exploring the Middle East. Church cared little for Europe; it was Syria, "with its barren mountains and parched valleys," that possessed "the magic key" which unlocked his "innermost heart." Church's wife, mother-in-law, and one-year-old son, Freddie Josie, accompanied him. As dashing Rosalie Bierstadt was primping for the fancy parties, spunky Isabella was becoming a celebrated donkey rider. The white Baghdad donkeys were her favorites—the faster, the better.

Without the two celebrities composing huge masterpieces be-
hind locked doors, the Tenth Street Studio Building became a quieter
place. The restless Martin J. Heade took advantage of the lull, left
Boston, and moved into Church's vacated studio. In the National
Academy Exhibition of 1868, he exhibited one of his most startling
paintings, "Storm over Narragansett Bay." It is a dark, eerie coastal
scene unlike anything that was done at the time. The critics did not
respond well to such a gloomy work. One of them wrote, "It is to be
regretted that so hard and chilling a painting as this should have been
allowed to leave his studio." Nature was meant to reflect beauty; not
to serve as the vehicle for the expression of an artist's dark mood.
Having emerged from a century of subjective art, today however we
can appreciate "Storm over Narragansett Bay" as one of the most
brilliant and unique paintings to come out of the nineteenth century.

In a nearby Broadway studio another bachelor, John Kensett,
was working on a painting of Lake George commissioned for three
thousand dollars by Morris Jesup of New York. Kensett shied away
from brilliant color. He depicted overcast days in quiet, gray tones.
Although his light may have been somber, his work convinced the
viewer that he was painting nature's sadness—not his own.

Gifford had been fidgety all winter. Finding the slackened activ-
ity unfruitful to his work, he decided to travel once again. One day
in June he walked into Whittredge's studio with a satchel on his
shoulder, and bid him good-by as if he were going to Coney Island
for a walk. He left his studio door open with a finished painting on
the easel, and a card indicating where it was to be delivered. He
visited Egypt, Jerusalem, Lebanon, Syria, Greece, and Turkey,
catching up finally with Church in Rome in the winter of 1868–69.
A year and a half later he returned home with the same satchel on his
shoulder. He ordered breakfast from the janitor, inquired if all were
well, and returned to work as though he had never been away.

Art devotees at home waited eagerly for Church's Middle East-
ern canvases to be placed on exhibition. Expectation rose to such
heights that one critic wrote: "A new picture by Church is a consid-
erable event in the art world, like a new novel by Victor Hugo or a
poem by Tennyson." They were not disappointed. Church had
turned his attention from nature's wonders to man-made wonders.
Once again crowds stood six people deep in front of his large city-

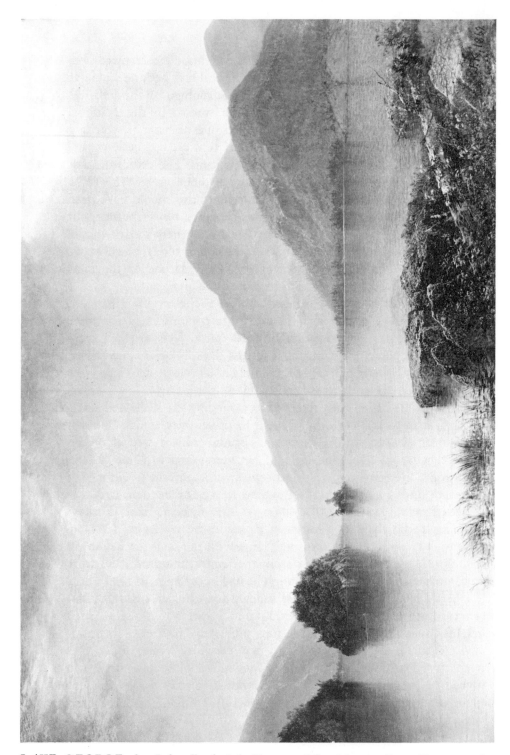

LAKE GEORGE, by John Frederick Kensett. The Metropolitan Museum of Art, Bequest of Maria De Witt Jesup, 1915.

scape "Jerusalem" when it was exhibited at Goupil and Company in 1871. A diagram identifying twenty-four places of interest in the panoramic view of the Holy City was available to the spectators. It had received tremendous acclaim from the press. The popularity of much of Church's work rested on the novelty of his subject. He had painted another place that few people of his day would ever see at firsthand.

During a year and a half spent abroad living in rented houses and painting in rented studios, Church had dreamed of building his own house. Almost immediately on his return to New York, he turned his attention to its design. He consulted the well-known architect Calvert Vaux on the basic construction of the house. But more than a dozen designs for the banister of the staircase, drawn in Church's own hand, provide evidence of the amount of personal effort that he himself put into the creation of this great house which he called Olana.

Olana, which still stands today on a hilltop on the Church farm in Hudson, New York, means "Our Place on High." It overlooks the Hudson River, beyond which the Catskill Mountains can be seen. On the opposite shore stands Thomas Cole's house, then occupied by his son, Theddy, who managed Church's farm. The architecture of Olana retains a Middle Eastern flavor. Large and elaborate, it contains thirty-seven rooms, and is embellished with broad piazzas, carved balconies, and square towers—one of which is adorned with Church's own playful creation—ceramic teapots! On the interior the doors are stenciled in Islamic designs and Turkish rugs are laid on patterned wall-to-wall carpeting. A yellow-glass window bathes the hall in amber light. It is furnished with Persian tables inlayed with colored foil, carved Chinese teak tables, bentwood dining chairs, and ottomans upholstered in robin's-egg blue. Tiffany glass, Japanese bronzes, and a gold Buddha located under the stairway add to the variety of samplings of world culture found there. Church's compulsion to be all-inclusive in everything he did is revealed in the lavish and assorted decoration of his home, but his Yankee thrift turns up in the manner in which he devised the large leaded glass window in the Court Hall. Rather than having each piece of glass fixed into a lead frame, he slipped delicately cut pieces of black paper between two large plates of amber glass to give the appearance of a stained-glass window.

Church intended to have "one old room" in his house "with old furniture and old pictures—everything toned down to 400 years back." For this room, which became the dining room at Olana, Church put together a collection of paintings which he referred to as "old masters." Bargaining for these so-called old masters in Rome (they were really copies) provided Church with many entertaining moments. He bragged that the highest price he paid was thirty dollars; the lowest one dollar. Church liked to pretend that he owned authentic paintings. He joked about opening his collection to the public. "Of course great names must be attached to the pictures—for faith works miracles . . ." he wrote. These dark paintings in elaborate frames line the walls of the dining room today, and one finds that prankish Church did indeed attach a plaque with a famous artist's name onto each frame.

Church began spending summers at Olana with his wife and four young children, in 1872. Malkastan, some seventy miles down the river, had already been forsaken by the Bierstadts. They were a gay, fashionable couple, without children, who preferred to be on the move. The Churches, on the other hand, associated little outside their family and close friends. Church took great pride in his new home. "About one hour this side of Albany," he wrote, "is the center of the world—I own it."

XVIII

The Railroad Pierces the Wilderness

Since 1863 thousands of Chinese coolies had been working at backbreaking speed in the California mountains, blasting tunnels through hard granite, constructing trestles over dizzying ravines and laying the iron rails on the new roadbed. Many people had doubted whether the railroad could penetrate the snow-clogged passes and bridge the steep canyons of the Sierra Nevadas, but the momentous task had been at last completed. Now the Central Pacific crews worked fast and furiously to span the flat lands of the Nevada desert. They were racing to meet their rival, the Union Pacific force, which was laying its rails westward at a top speed of five miles per day.

The gap between the two railroad tracks approaching each other was fast closing. In May 1869, the meeting was set to take place in Promontory, Utah, north of the desert which Bierstadt had crossed at such peril in a stagecoach only six years earlier. Railroad presidents Leland Stanford and Thomas Durant waited among construction crews, soldiers, and other railroad officials, for the great moment

when they were to drive the gold and silver spikes into the ties. Specially wired to set off a telegraph signal, the spikes, when struck, informed the world that the continent was now linked by its first transcontinental railroad. It was a day that stirred the entire nation. The railroad had brought the Atlantic and Pacific coasts within a six-day journey of each other.

Legrand Lockwood could experience the magic of Yosemite Valley through Bierstadt's brush whenever he stepped into the rotunda of his mansion in Norwalk, Connecticut. He had been considering how others could thrill to the reality of the country's scenic wonders without giving up the comforts of home. It was not long before Lockwood came up with a specially designed "palace" railroad car with dining service and plush seats that converted into berths at night. In 1871 Bierstadt took his wife in a "palace car" across the country to the West Coast. Eastern critics had begun to confront his painting with harsh criticism. He expected to find a more generous welcome in San Francisco, where they hoped to spend the next few years.

After the first blush of enthusiasm for Bierstadt's grandiose "Rocky Mountains," the critics began increasingly to find fault with his paintings. They contended that his paintings "astound but do not elevate," and emit "no depth of feeling." In an effort to maintain his stylish way of life from income earned entirely from his work, Bierstadt sometimes dashed off commissions, not devoting the time to detail that gave such richness to Church's work. Moreover, he composed much of his work according to a formula. He used the same elements over and over again—juxtaposing a grove of trees, waterfall, mountain or animal into various positions on his canvas. Thus, he began to produce many paintings that looked alike, selling them as fast as he could paint them. Bierstadt was not able to transform natural scenery into the contemporary symbols suggested by Church's landscapes. Although critics preferred Church's more profound interpretation, Bierstadt remained first with the people. Americans wanted to know what their country looked like, and no other artist was capable of arousing such pride in the nation's scenic wonders as he was.

Bierstadt had already painted Mount Shasta, Mount Hood, and Mount Rainier—the famed conical mountain of the northwest—then

thought to be the highest in the country. But since his last trip, the even greater heights of the Sierra Nevadas had been discovered. The year of Bierstadt's arrival in California, a leading geologist and member of the Josiah Dwight Whitney surveying group, Clarence King, thought that he had been the first to reach the summit of the 14,495-foot Mount Whitney, proclaiming it the highest mountain in the United States. After he had written a book about his feat, he discovered that he had mistakenly climbed a lower peak while Mount Whitney had remained hidden by storm clouds. The persistent King set out to conquer the new peak only to discover from names carved in the granite that some climbers had already reached the summit.

While the controversy raged as to who had first climbed the elusive peak, Bierstadt, capitalizing on the publicity, was turning out numerous Mount Whitney paintings for an eager public. Using his customary knack for flattery, Bierstadt named his most famous Mount Whitney painting after Colonel William Corcoran in hopes of encouraging the colonel to purchase it for his museum. The painting, titled "Mount Corcoran" (there exists no mountain by this name), hangs today in the Corcoran Galley in Washington, D.C.

Some of Bierstadt's most enthusiastic patrons were men who had amassed fortunes from the regions of which he was master painter. Leland Stanford's Central Pacific Railroad was bringing passengers by the hundreds through the scenic beauty that Bierstadt was making famous with his brush. His partner, Collis P. Huntington, took Bierstadt on a trip into the High Sierras soon after his arrival in San Francisco. Huntington was eager to have some of the rugged western territory through which his railroad ran immortalized by America's most popular artist. He commissioned Bierstadt to paint a view of the highest point that the Central Pacific Railroad passed over. Bierstadt completed a massive work for Huntington, over twelve feet long, entitled "Donner Lake from the Summit," for which he apparently obtained another fabulous twenty-five thousand dollars.

When it was exhibited in San Francisco, the local critics could find no fault with the work of art. They described it as the "art-sensation of the city," and attributed to it some of the characteristics that Mark Twain had found true a number of years earlier of Church's "Heart of the Andes." "If you take your lorgnette with you and look with an intelligent eye, you can discover new beauties

every moment; and the oftener you see it the more impressed you will be . . ." wrote a critic on the San Francisco *Chronicle*.

When Bierstadt was not on a sketching trip, he worked in a studio he had built on the top of Clay Street overlooking San Francisco Bay and the Golden Gate. He painted views of Sacramento and Monterey Bay. A painting of seals prancing among the rocks on the Farallon Islands, some twenty miles off the coast of San Francisco found its way to the New York mansion of A. T. Stewart, Cyrus Field's first boss. By October 1873, Bierstadt and Rosalie returned to New York where he continued to work up his West Coast sketches into full-sized paintings.

Meanwhile, Kensett and Gifford had taken their first trip West, going only as far as the Rocky Mountains. Whittredge, who accompanied them, left his impressions in his *Autobiography*. He found that the vastness and serenity of the prairie inspired him more than the height and grandeur of the Rockies. With perhaps some envy at the enormous prices that Bierstadt's work was bringing, he questioned why the public made such a fuss over paintings of mountain scenery. He had never measured "all grandeur in a perpendicular line," he explained.

Kensett and Gifford were also attracted to subjects that offered horizontal rather than vertical lines. They rarely attempted the enormous views that appealed to Bierstadt and Church. They preferred to paint medium-sized canvases that were more appropriate to drawing-room walls than exhibition galleries. Having more modest appeal, they never received the massive attention from the press or the high prices accorded their more showy contemporaries. Their paintings, however, were loved by the people, welcomed by the critics, and were bringing such good prices that they were able to live comfortably. Although Bierstadt and Church sent paintings regularly to the National Academy exhibitions, their large-scale works were generally exhibited as single attractions at commercial galleries. Kensett, Gifford, and Whittredge continued to depend on the National Academy as their primary showplace, along with hundreds of other artists.

As firm supporters of the National Academy, Whittredge, Gifford, and Kensett maintained a close friendship with Asher B. Durand, who, at age seventy-four, had decided to sell his city house and move back to the family farm in Jefferson Village, now grown

into a suburb of Maplewood, New Jersey. The old house no longer stood, but Durand built a new one, complete with a large studio. Over the years he had continued to paint directly from nature and was still annually exhibiting these finished studies at the National Academy.

Durand lived to such a ripe old age that he became the target of reporters from health journals who were anxious to learn the secret of his long life. His son tells the story that one day he was sitting on the veranda of his house when a reporter came by and began to pump Durand about his habits.

"Mr. Durand, I suppose that you have never used tobacco?" the reporter inquired.

Picking up his pipe, Durand answered, "Yes, sir, I have always used it; I smoke now, and when a young man, I chewed."

"Ah! But you did not drink ardent spirits. How is that?"

"Yes, sir, I have, and do so now. My daughter has just given me an eggnog with brandy in it."

The interviewer, getting nowhere, pursued another possibility: "Well, during your long life you have done a great deal of work?"

"That is true," Durand chuckled. "I have spoiled a great many canvases."

In 1872, Kensett, Gifford, Huntington, and another artist, Jervis McEntee—all grateful to Durand for the encouragement he had offered in their youth, invited friends to a party in honor of the aging artist. Bringing food and champagne from the city, they organized a surprise picnic to be held in the woods near Maplewood. Because of impending rain, the picnic was abandoned at the last minute in favor of a lunch served on the veranda. William Cullen Bryant, now wearing a long, white beard, gave a toast to Durand as the pioneer "of our pathways which have now become highways." Music followed in the drawing room, after which groups took walks in the woods. When evening came, the party whirled off to the railroad station behind four-horse teams, cheering and bidding good-by to the proud old artist.

Durand did not know that he would never again see his friend and student John Kensett. The following winter, Kensett caught pneumonia trying to save the drowning wife of a friend of his in Darien, Connecticut. He died of heart failure just before Christmas.

He was fifty-six years old. Kensett had been one of the kindest and most sociable of the group. He was deeply mourned by many people. The following spring, the contents of his studio were auctioned off for the total of $136,312. It surprised his friends that his unsold paintings and other possessions were worth so much.

In 1876 a huge Centennial Exposition was organized to celebrate one hundred years of American Independence. One hundred and sixty-seven new buildings were erected on a 236-acre site in Philadelphia in order to house the exhibitions of as many as fifty nations. A half-size railroad carried visitors past four and a half miles of pavilions, villas, gardens, lakes, and colossal statues. On display were products of all kinds—a hair regenerator from Switzerland, sugar-coated pills from Pennsylvania, dog soap from Britain, artificial manure from Argentina, salted reindeer tongues from Russia, etc. One of the highlights was a bust of a girl carved by an Arkansas woman, in butter!

The glass-domed Memorial Hall held the largest art exhibition ever seen in the United States. It contained thirty galleries, of which fifteen were devoted to American paintings. All the leading artists since colonial times were represented. Works by the deceased members of the Hudson River School, Thomas Cole and John Kensett, had been collected for the occasion. History paintings, portraits, still-life, and genre paintings hung on the walls, but landscape still held the dominant place . . . winning half of the medals awarded.

Whittredge, who was then serving as president of the National Academy, was in charge of assembling paintings sent from New York State. Church sent "The Parthenon," a recent depiction of the ancient Greek temple, and "Chimborazo," painted some twelve years earlier, but seen in public for the first time. Church, Cropsey, Whittredge, Bierstadt, and Thomas Moran, another Rocky Mountain painter, were praised for their work, but Gifford, who sent the largest number of paintings, also walked away with the largest number of awards.

None of the paintings in the gigantic art section gave any visible sign of the industrial expansion that was about to revolutionize the country. The era of exploration represented by the picturesque views and sunny landscapes was about to come to a close. The key to America's future lay in the clattering, chugging, roaring galleries of Machinery Hall. As far as the eye could reach machines of all kinds

were on display. They were run by one giant steam engine. Each day at one o'clock the engine would stop for an hour. Crowds gathered to watch it being set in motion again. As the giant flywheel began to turn, and all the shafts, pulleys, and belts in the hall went into action, the deafening roar of churning engines and cheering crowds filled the air.

After the close of the Philadelphia Centennial the public began to visualize another world. The locomotive had invaded the wilderness. Faith in nature gave way to faith in the machine. Hopes for mankind now lay in technology and industry. A new era had begun.

XIX

The Decline

As Europeans returned home from the Philadelphia Centennial talking of the power and inventiveness of American machinery (suspecting they might lose their industrial dominance to the new country), Americans were returning home from Europe talking of their excitement and admiration for modern French landscape. They had discovered the intimate nature scenes of the Barbizon School—the same group of French artists that Whittredge had visited and rejected many years earlier. Now, the traveling horde purchased Barbizon paintings by the hundreds—works by Rousseau, Diaz, and Corot were beginning to replace American landscape on drawing-room walls. Collecting foreign works of art was becoming a mark of worldliness.

Young American artists studying abroad also returned with the conviction that there was much to be gained by looking to Paris and Munich (which had replaced Düsseldorf) for leadership. In the 1870s Paris was a hotbed of artistic revolt. The Barbizon painters, who had been outcasts a decade earlier, had finally been accepted. Another

group called the Impressionists, who broke up form into myriad brilliant colors, suffered through years of ridicule before they gained recognition later in the century. These French influences began to flood American art during the last decades of the nineteenth century, and severely challenged the influence of native landscape.

As the young artists returned to New York, many of them settled into the Tenth Street Studio Building where Church, Bierstadt, Heade, and Gifford were still producing their awe-inspiring scenery and luminous landscapes. The old-timers were shocked and bewildered by the radical ideas of the young. Subject matter made little difference to the new generation. Many cared nothing for nature, and had rather paint a vase, pot, figure, or even a dead fish than America's scenic beauty. They cast aside the subdued brush stroke that gave priority to the subject, in favor of flashy brushwork that often obscured it. The viewer who wanted to imagine himself strolling through the canvas into a lovely landscape was now obstructed by such a rich, elaborate surface that it became the sole reality. The new generation believed that the quality of a painting rested entirely in the mastery of technique.

Since the first decades of the century the highest compliment paid to a work of art was to call it truly American. Now, the young artists scoffed at implications that their art had to be characteristic of their own country. They considered American art provincial. They wanted their paintings to be compared favorably with the Munich and Paris schools. The hopes and dreams of the old generation for the continuation of a unified national style were collapsing all around them.

Conflicts between the young and the old came to a head during Whittredge's term as president of the National Academy—still the major showcase for both established and unknown artists. Hundreds of works of art were submitted to the annual exhibitions—far more than there was space to exhibit. Each year different artists were appointed to serve on the three-man hanging committee. One year the hanging committee included many works by younger artists, which meant that a number of paintings by long-established members had to be rejected. The old guard became outraged, and some of Whittredge's closest friends sent letters of resignation. With Bierstadt serving on the committee the following year, it bent in the opposite

direction, and the younger generation found themselves without a place to exhibit. They accused the National Academy of being ruled by a clique of stodgy old men who favored social position over genius. Scruffy old George Inness, a talented but unappreciated artist of the same age as Church, had over the years felt out of place there. Inness complained that an artist who kept "his nose clean and his shoes well-brushed" carried more weight than one with artistic talent. Just as the National Academy had been created fifty years earlier, the outcasts now gathered together, and by the fall of 1878, opened their own exhibition under the name of the Society of American Artists.

As revolt was stirring in the art world, Church was reaffirming the value of the wilderness in a glowing masterpiece entitled "Morning in the Tropics." It is a painting of a broad, silent river flowing through a thick jungle in the glowing light of evening. Here there were no locomotives to smoke and whistle, no riverside settlements to corrupt and pollute; there was only the silence and mystery of undisturbed nature.

The remote beauty of the wilderness held no meaning to the new generation. Church's painting looked out of date. When the young novelist Henry James saw one of Church's works, he remarked, "Why not accept this lovely tropic scene as a very pretty picture, and have done with it?"

On his return to New York from California, Bierstadt had continued to turn out paintings of Mount Whitney. The sparkling light and crisp color makes these some of his finest work, but changing tastes had taken a bite out of the twenty-five thousand dollars he had been accustomed to charge for his major paintings. To make up for the loss, he rented Malkastan in summer, residing in the more modest home of Rosalie's family in Waterville, New York.

Whenever there was an opportunity to associate with the rich and powerful, the Bierstadts were certain to be there. They had made such a favorable impression on Lord Dufferin, governor-general of Canada, on his visit to the United States, that he gave them honored places at his celebrated costume ball. Rosalie arrived dressed as Mary, Queen of Scots, in a costume of white puffed satin and silver-embroidered velvet. Albert was outfitted as Charles I in white stockings, knee breeches, velvet cape and fringed hat. Jingling sleighs

carried them over the snow to the hall lit by hundreds of candles and decorated with festoons of roses, where they danced until five in the morning.

When the Earl of Dunraven, author, traveler, and sportsman, came to the city, Bierstadt took the opportunity to entertain him so lavishly at the Brevoort Hotel that the newspapers reported that the distinction of the gentlemen and the extravagance of the menu had "seldom if ever been excelled." Bank and railroad presidents dominated the table. Bierstadt was hoping to receive a commission from the earl to paint a view in Estes Park, Colorado. The earl, who had just acquired ten thousand acres of this beautiful land, decided to give Bierstadt the opportunity to preserve it on canvas. He received fifteen thousand dollars from Dunraven for the final painting, which was just slightly smaller than his famed "Rocky Mountains." His prices had fallen, but the quality of the painting was as fine as the best of his western views.

The changing perceptual awareness of the late 1870s affected the other artists in various ways. Cropsey busied himself with architectural plans for the stations of the Sixth Avenue Elevated Railroad. He designed a colorful interior for the Seventh Regiment Armory on Sixty-sixth Street between Park and Lexington avenues. (No trace of either remains today.) And he continued to produce vivid autumn scenery in the tradition of Cole. His prices had declined—so much so that he was forced to sell Aladdin, the twenty-nine-room Victorian mansion which he had built many years before in Warwick, New York.

With his long European training and more lively brush stroke, Whittredge adapted more easily to the new styles. He tried his hand on current subjects such as street scenes and vases of flowers. He loosened his brush stroke and lightened his color to give a contemporary effect. Martin J. Heade maintained the sleekness of his style, but gave up landscape for the more fashionable still-life as his major subject.

Running away with so many awards at the Philadelphia Centennial did not make Gifford happy. His friends noticed that he appeared depressed. Perhaps he already knew he was in bad health. He did have some serious concerns on his mind, because the following spring he was secretly married. But fate did not intend Gifford to

enjoy long years of marital bliss, as he passed away soon afterward, at fifty-seven years of age.

By 1880 the population of New York had soared over one million, and thousands of immigrants continued to pour in. The city had spread up Fifth Avenue with the great, baronial mansions of railroad kings overlooking the lakes, fountains, and meadows of the newly opened Central Park. The Metropolitan Museum, another promotion of the late William Cullen Bryant, opened its new building on Eighty-third Street and Fifth Avenue in a ceremony led by the President of the United States, Rutherford B. Hayes. Downtown the first masonry skyscraper was on the planning board—a twelve-story-high project of the still-energetic Cyrus Field. Electric arc lights had been installed on lower Broadway, and within two years Thomas Edison's giant dynamo would supply electricity to homes and shops. The overhead wires of New York's first telephone exchange already cluttered the sky.

Observing the miraculous changes around him, Frederic Church, sitting on his veranda at Olana, remarked, "I wish science would take a holiday for ten years so I could catch up." The day of the Baron von Humboldt had passed—no man could keep abreast of the vast quantities of new knowledge. Moreover, Darwin's theories of evolution and the survival of the fittest were finally taking hold. Attacking the divinity of creation, Darwin's theories undermined Church's purposeful concept of the universe. Once the believer, he became the doubter, and the art which no longer held meaning for the public, no longer held meaning for him.

Only a few feeble paintings ever again came out of Church's studio. Rheumatism began to cripple his right hand. He continued his interest in the art world as a trustee of the Metropolitan Museum. (Kensett, until his death, had also been a trustee.) He continued his interest in landscape by serving on the board of commissioners of the Department of Parks, and applying his creative ability to designing the grounds around Olana. He wrote to the sculptor Erastus Palmer, "I have made about one and three quarter miles of road this season, opening entirely new and beautiful views—I can make more and better landscapes in this way than by tampering with canvas and paint in the studio."

Church had also been carrying on a lively correspondence with

Heade, who up to this time had been working in Church's studio in the Tenth Street building. At sixty-four years of age, never having been married, Heade was considered a confirmed bachelor, but the year 1883 found Church writing, "I'd heard that you bought a house in St. Augustine. That surprise gives way to the greater one of your engagement—not that extraordinary but I hadn't heard you were interested in any particular lady." Heade had at last found financial security in the patronage of the Standard Oil Company vice-president, Henry M. Flagler, which, after all these restless years, enabled him to marry and settle down. In Florida, Heade continued to paint work of great originality, putting his energies into a powerful series of tropical landscapes and radiant still-lifes of magnolia blossoms and Cherokee roses.

In Maplewood, New Jersey, the aging Asher B. Durand sat at his easel working on a painting of a sunset in the Adirondacks. After it was finished, he laid down his brush and remarked sadly to his son, "My hand will no longer do what I want it to do." He had painted his last painting.

One night in Irvington, New York, Bierstadt's neighbors were awakened by the smell of smoke and the redness of the sky. In nightcaps and gowns they stood on the hill watching the flames tear into the midnight sky. Malkastan was burning; the next day only the ashes and chimneys remained. Many of Bierstadt's sketches and possessions were burned with it.

The Paris Exposition of 1889 offered artists another opportunity to exhibit their work to an international audience. Bierstadt searched desperately for new material. Thumbing through his old sketches he came across some studies he had made of buffalo during his 1863 trip West. The plains had been covered with herds of buffalo as far as the horizon. Such a sight, unique to America, was a natural wonder in itself. Few Easterners had seen it, and with the massive killing of buffalo, the spectacle was destined soon to disappear. The paper had yellowed with age, but the quick little sketches of the wounded bull —its tail erect and its eyes glaring—taken just before the marksman fired the last shot, were still vivid and fresh. He decided to use them as the basis for a large and intricate composition which he hoped to be the crowning painting of his western themes.

Seventeen American artists sat on the selection committee for

the Paris Exposition. When "The Last of the Buffalo" came before them, they unanimously voted to reject it. The public had tired of paintings of the West; the realistic technique looked old-fashioned. Bierstadt had to face the cruel fact—his paintings had gone out of style.

Other circumstances began to deteriorate for the artist. The once beautiful, vivacious Rosalie had been ill for many years. She was slowly dying of tuberculosis. Bierstadt's paintings were selling more slowly. With his enjoyment of elaborate entertaining and the accumulation of doctors' bills, Bierstadt was falling into debt. In 1893, Rosalie died.

Bierstadt was quick to secure the hand of wealthy Mary Hicks Stewart, who was the stepmother of the well-known Boston art collector, Isabella Stewart Gardner. Rather than have his new wife pay his debts, he declared bankruptcy shortly after his marriage. He and his second wife spent their time traveling to fashionable resorts in Europe and America, where Bierstadt met elderly clients who still appreciated the western scenes which he continued to paint.

The Tenth Street Studio Building took on a different atmosphere with the old landscape painters gone. The new movement centered in the exotic studio of William Merrit Chase. Visitors to the building no longer met restrained, modest artists working industriously at their easels in plain, dark suits. If they entered Chase's studio, they were met by a fez-topped servant, and a dapper artist with a carnation in his buttonhole and a scarf pin for each day of the month. Nibbling on his fingertips and jiggling trinkets in his pockets, he told his students, "Take plenty of time for your pictures—take two hours if you need it." In open rebellion against the past, he taught that laborious execution of detail was a sign of bad art. As the most articulate proponent of new ideas, Chase became the most influential teacher at the turn of the century.

In Montclair, New Jersey, another eccentric artist could be found working in such a frenzy that he splattered paint over his canvas, himself, and the studio walls. George Inness had struggled with the Hudson River style through its years of popularity. He had often doubted whether his paintings gained meaning from the elaborate detail that the public craved. Nor did he seem to be able to prevent his high-strung temperament from interfering with an objective view of

nature. After he discovered that the Barbizon painters were exploring landscape in a way more compatible to him, he made radical changes in his style. He no longer modeled his large paintings after carefully planned sketches, but improvised directly on the canvas from memory and inner feeling. Grand views no longer interested him; his backyard was quite good enough for the effects he desired. When the tide began to turn away from the Hudson River style, Inness was still an unrecognized artist in his mid-fifties. As the public lost interest in Church and Bierstadt, they discovered the genius of Inness, and his moody landscapes became the most sought-after paintings of the late nineteenth century.

Church, Bierstadt, Heade, Whittredge, and Cropsey lived to see the Hudson River School become the object of contempt. Cropsey and Church died in 1900. Two years later, Bierstadt passed away, and then Heade. As Whittredge saw his friends die, he sat down to write his memoirs in his *Autobiography*, leaving a valuable document of the times in which the Hudson River artists flourished. By the end of the decade the major figures were all dead, and their paintings had been forgotten.

GLENWOOD SPRINGS PUBLIC LIBRARY

BARBARA BABCOCK LASSITER, a native of North Carolina, majored in art history at Smith College and attended Parsons School of Design. She has written articles and catalogues on American art. As Visiting Lecturer of Art History at Wake Forest University and President of Reynolda House (which houses an extensive collection of paintings by major American artists), she is actively engaged in the encouragement of art education in America through her seminars, exhibitions, lectures, and writings.